HOW TO PAINT
LANDSCAPES IN OILS

DAVID CRANE

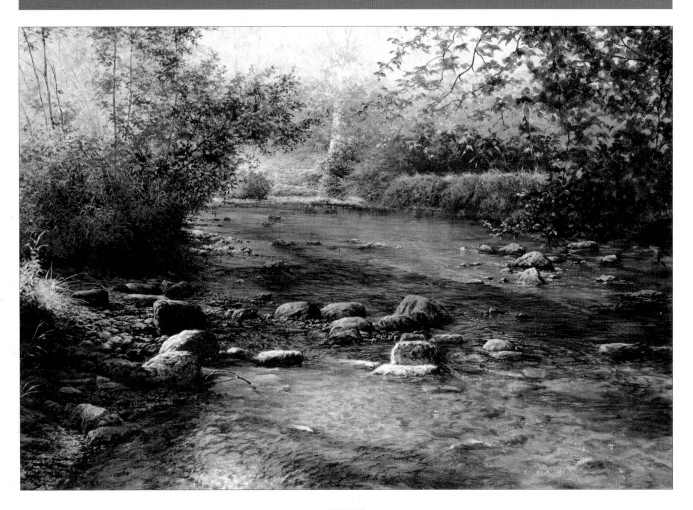

SEARCH PRESS

First published in Great Britain 2009

Search Press Limited
Wellwood, North Farm Road,
Tunbridge Wells, Kent TN2 3DR

Text copyright © David Crane 2009

Photographs by Debbie Patterson, Search Press Studios;
and Roddy Paine Photographic Studios

Photographs and design copyright © Search Press Ltd. 2009

ISBN: 978-1-84448-420-1

The Publishers and author can accept no responsibility for any
consequences arising from the information, advice or instructions given
in this publication.

Suppliers
If you have difficulty in obtaining any of the materials and equipment
mentioned in the book, please visit www.winsornewton.com for details
of your nearest Premier Art Centre.

Alternatively, please phone Winsor & Newton Customer Service on
020 8424 3253.

Publishers' note

All the step-by-step photographs in this book feature the
author, David Crane, demonstrating painting landscapes in oils.
No models have been used.

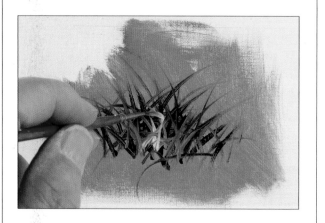

Printed in Malaysia

Acknowledgements

*To all at Search Press, especially my editor
Katie, and Roz and Debbie. Thank you for
your patience and coffee. Thank you also
to those people I have had the pleasure of
teaching. This forced me to crystallise my
knowledge and to want to help others to enjoy
the pleasure of painting.*

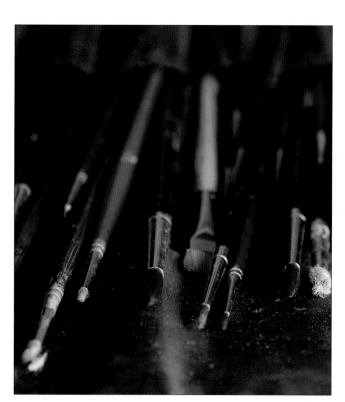

Cover
Autumn Hues
40.5 x 30.5cm (16 x 12in)

Page 1
Bluebell Trail
40.5 x 30.5cm (16 x 12in)

Page 3
Stepping Stones
76 x 51cm (30 x 20in)

Contents

Introduction

'If only I had your talent, I'd have a go at painting too. It must be wonderful to have such a gift.' I am often confronted by people who say these, or similar, words, and the answer is, 'You do'! Believe in yourself, put in some practice, develop confidence in your ability and you will be amazed at the results.

I believe that all of us have, to a greater or lesser degree, the ability to portray our perception of the world, whether it be through writing, music or art. My particular talent, which I have developed over many years, is an ability to depict the countryside through painting in a way that many people can associate with and find pleasing. I have had a passion for art since my schooldays and I am largely self-taught, with the result that I was not steered at an early stage towards any one particular style but formed my own techniques and artistic approach. I am now delighted to have the opportunity to pass on this knowledge of how to paint in oils.

Wherever you are on the 'painting ladder' it is important to continuously strive to improve, to try out new ideas and always push to achieve higher standards within your work. Without this need to do better, your work can become stale and you can lose motivation. This maxim applies to many areas of life, but is demonstrated particularly within the work of the artist. Art lovers will often comment on particular pieces of work being a 'window to the soul', and when we consider the time involved in putting oil on canvas, building up each section layer by layer, fretting over its accuracy or how a particular area is portrayed or will be perceived, it is not hard to see how so much of the artist is brought to the canvas using the medium of oils.

I have always loved using oils. They have a depth of colour and luminosity I have not been able to capture with any other medium. However, oils are not as popular as, say, water colours or acrylics, because of a number of misconceptions. First, oils were the choice of many of the Great Masters and this fact alone can be intimidating. Secondly, there is a common perception that oils are messy, smelly and can end up muddy. In this book I will show you how to overcome these taboos and give you the confidence to enjoy painting in the truly versatile medium of oils.

In the past, I have often been asked how I achieve my paintings. This has forced me to break them down into the component elements of composition, perspective, draughtsmanship (or the ability to draw), colour, tonal values (the use of light and dark) and the creation of three-dimensional effects. This analysis has formed the basis of this book. In more recent years the use of light within a painting has become a particularly important aspect of my work, and I will talk about this in some depth. It is worth noting that all these components are integral to any painting and are only isolated here to be able to understand and learn about each one more easily.

I hope that this book will encourage you to experiment with your art. Accompany me on this journey and I will pass on to you the techniques and skills that I have developed over the past 30 years of painting landscapes in oils. Let's get going!

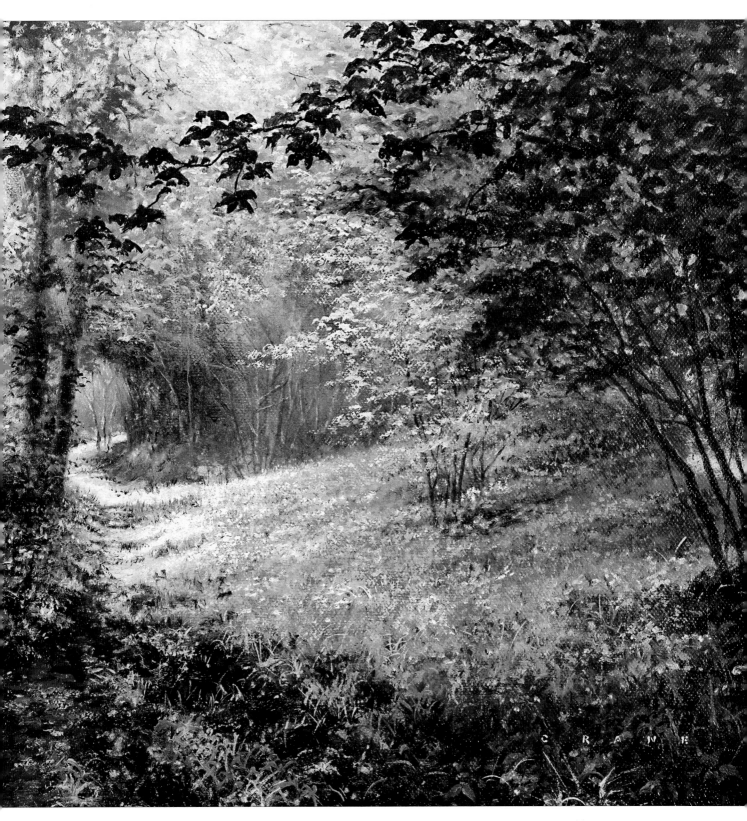

Kingswood
40.5 x 30.5cm (16 x 12in)

The idea for this painting was inspired by a Cornish woodland. I have used the woodland flower of spring – the bluebell – together with pink campion to give colour. Note the top lighting used to suggest height outside the painting.

Materials

All painters will differ in their individual selection of materials, but the key items are: paints, brushes, canvases, painting medium and brush cleaner.

Oil paints

It has often been accepted that using a limited palette is beneficial, as it forces the painter to acquire colour mixing skills and it gives a painting unity. Over the years I have gravitated towards a palette that consists of the colours shown on the facing page. This is a relatively wide palette and I would not expect to use every colour in every painting, though I generally lay out all of them before I begin to paint. If I am completely immersed in my work and have a sudden desire to add a colour that is not immediately available, the moment of inspiration could all too easily be lost while I am searching for it in my paintbox! Lamp black and raw umber are additional to my everyday palette, but I always have these readily to hand. If you are just beginning your venture into oil painting, this wide palette may seem a little formidable, but I would suggest you invest in as many as possible so as not to miss out on that moment of inspiration!

Although I would recommend using artists' oil colours on the basis of their excellent quality, Winsor & Newton student colours are a very good choice where cost is an issue. Try to experiment with the different colours of oil paints as the consistency and strength of each colour will vary with the pigment. Raw sienna, for example, is quite translucent, whereas alizarin crimson has a strong tinting strength and only a little paint is required.

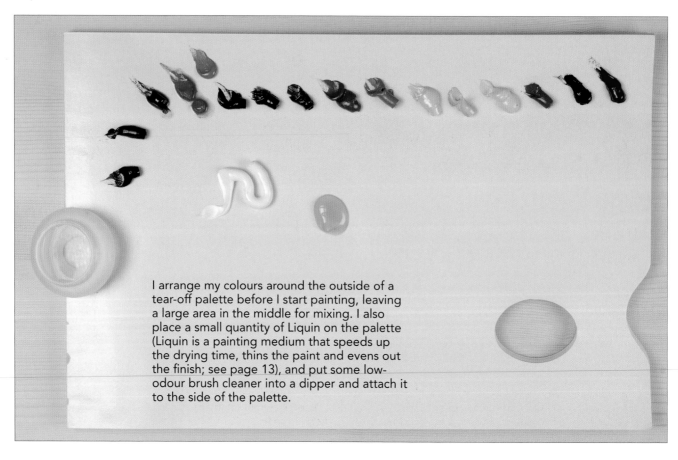

I arrange my colours around the outside of a tear-off palette before I start painting, leaving a large area in the middle for mixing. I also place a small quantity of Liquin on the palette (Liquin is a painting medium that speeds up the drying time, thins the paint and evens out the finish; see page 13), and put some low-odour brush cleaner into a dipper and attach it to the side of the palette.

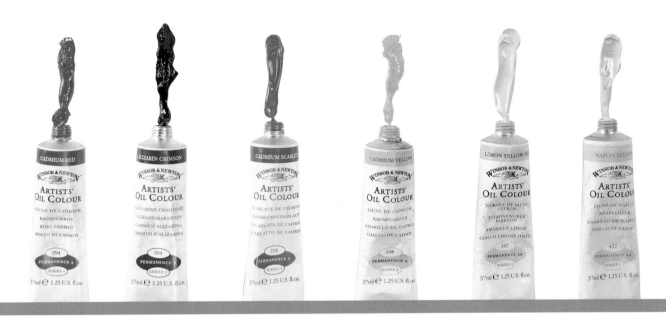

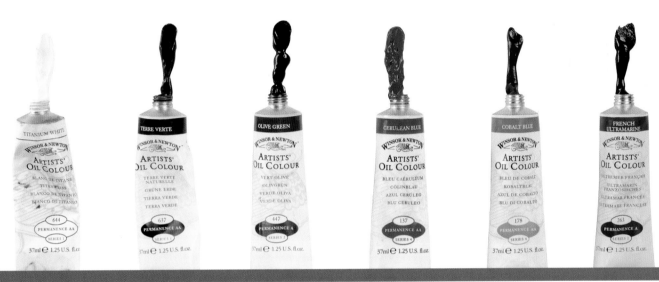

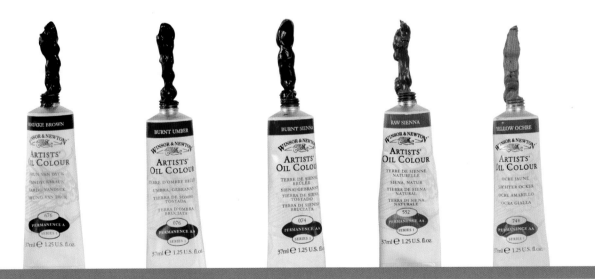

The colours in my palette are, from top left to bottom right: cadmium red, alizarin crimson, cadmium scarlet, cadmium yellow, lemon yellow hue, Naples yellow, titanium white, terre verte, olive green, cerulean blue, cobalt blue, French ultramarine, Vandyke brown, burnt umber, burnt sienna, raw sienna and yellow ochre.

Brushes

Good quality brushes will considerably aid your ability to obtain the effects you are seeking in your work, and in my opinion one of the most common reasons for dissatisfaction in one's work will have its foundation in poor quality brushes. For the particular techniques that I have evolved in my work, I generally find that brushes made from either a mix of pure sable and synthetic fibres, such as Winsor & Newton's Sceptre Gold II range, or pure polyester, for example the University and Artisan ranges, work best. I do not often use hog brushes as I prefer a more flexible bristle, and the Artisan range is ideal for this purpose. I tend to avoid pure sable brushes as I find these are better suited to water colours and acrylics rather than the viscous properties of oils.

I have collected many different types of brushes over the years, but in order to achieve all the techniques covered in this book you will need only a small number. As your skills develop you may want to experiment with a wider selection, but for now I would recommend you buy a fairly stiff, all-purpose synthetic brush such as a University size 2 round for general work, a few softer, sable/synthetic brushes in a range of shapes and sizes, and a soft mop brush for blending. A size 2 round and a size 2 flat brush from the Sceptre Gold II range of sable/synthetic brushes are ideal for fine work; a size 0 flat is excellent for individual leaves; and the lettering brush from the same range is a good alternative to a half rigger and can happily be used for grasses (a rigger is a small, round brush with long hairs). Another general-purpose brush for applying large areas of paint is the Artisan size 12 flat. This is also useful for the vertical and horizontal strokes of water, as is the smaller Artisan size 2 flat/bright, which has shorter hairs than a standard flat. Examples of each of these brushes are shown opposite.

Customising your brushes

If you cannot find the exact type of brush you need for a particular purpose, do not be afraid to modify one of your existing brushes. I use old, rough brushes with some distorted bristles for creating background foliage by stippling (see page 11).

I will often take a size 1 round acrylic brush and, with a pair of nail clippers, carefully remove about a third to a half of the bristles. This effectively gives you a quarter rigger. It still retains its spring and point, but is a little more controllable than a half rigger.

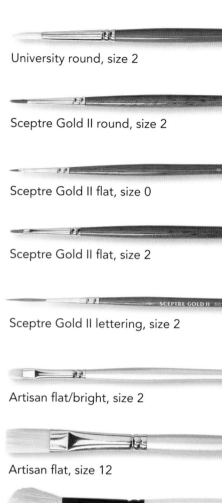

University round, size 2

Sceptre Gold II round, size 2

Sceptre Gold II flat, size 0

Sceptre Gold II flat, size 2

Sceptre Gold II lettering, size 2

Artisan flat/bright, size 2

Artisan flat, size 12

Mop brush, size 1

Mop brush, 19mm (¾in)

1 Using a pair of nail clippers, carefully remove some of the hairs from a size 1 round acrylic brush.

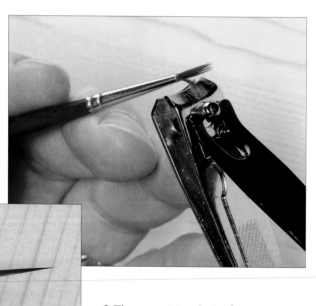

2 The remaining hairs form a fine-pointed brush that is ideal for painting minute detail.

These old, rough, uneven brushes are invaluable for stippling.

Brush techniques

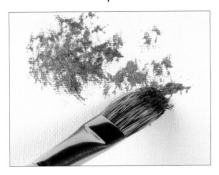

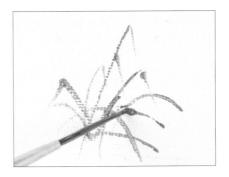

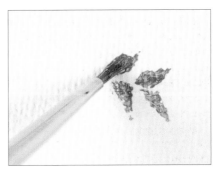

For stippling, which I use to achieve background foliage, you will need a fairly wide, stiff brush such as a goat hair mop, although personally I prefer to use one of my own custom-made 'stippling' brushes (see page 10).

For fine branches and grasses, use a small brush with a long, thin point, such as a half rigger. A Sceptre Gold II lettering brush, which has good paint-carrying capacity and is designed to create long, clear lines, is also excellent for this purpose.

Add detailing, such as individual leaves, using a small, fairly soft flat brush such as the Sceptre Gold II size 0. Use the flat side to create broad strokes, and the fine edge for thin lines.

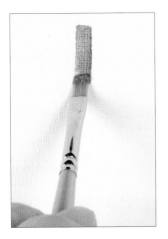

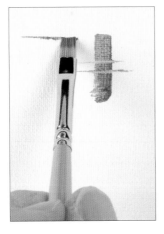

A more rigid, synthetic flat brush can be used to create a single, broad stroke or, flat on, a fine line. The Artisan range consists of polyester brushes that retain their spring and shape well, making them, in my opinion, more suitable than a hog brush for oil painting.

Use an Artisan flat, size 12 or similar short, flat brush to scrub paint on over a large area.

A 19mm (¾in) mop brush is excellent for removing brush strokes and for moving colours around in a background. It can also be used for blending subtle colours together, for example in skies.

A synthetic round brush is extremely useful for a wide range of purposes. The University round is stiff enough to use with oils, and the polyester fibres make smoother marks than a hog brush.

Palette knives

Palette knives come in a variety of shapes and sizes. I use a small knife for occasionally applying paint where a heavier impasto is required and a larger, flat knife for removing excess paint (see page 61).

Canvases

I use a Winsor & Newton medium-grain linen canvas for all my work because it suits my application of oil paint. It has the right 'tooth' to grip the paint but is fine enough for delicate work. However, I would suggest cotton canvases if you are relatively inexperienced, as they are more affordable and therefore less inhibiting; it is important not to restrict 'creative experimentation' because of the fear of wasting materials.

Canvas boards are also available, but I prefer the response of a stretched canvas rather than the solid feel of a board. However, this is a personal preference, and you should experiment to find which type of canvas suits you and your style of work best.

A variety of pre-stretched canvases, canvas rolls and canvas boards, all sized and acrylic primed ready for use.

Palettes

I have used tear-off paper palettes for many years. They are made of disposable vegetable parchment and are impervious to oil colour. I would suggest getting the largest available so as not to cramp your colour mixing. Each palette sheet will last three or four painting sessions before it is full and needs to be discarded. If you prefer a solid, washable palette that will last a life-time but require cleaning in-between painting sessions, these are available in a range of sizes and finishes, including mahogany, birch and melamine faced.

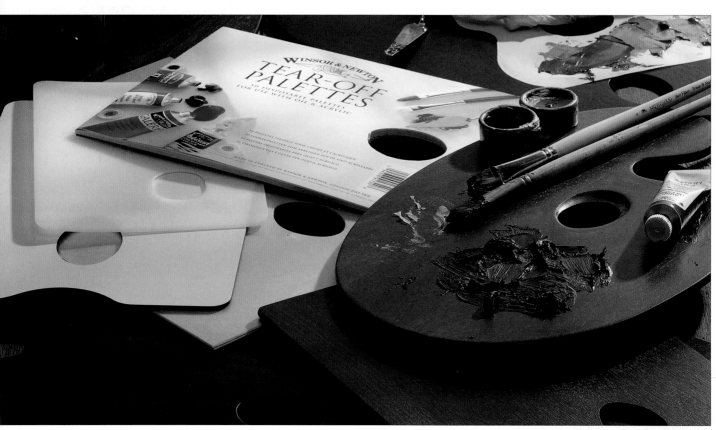

A wide variety of palettes is available, in many different sizes and finishes.

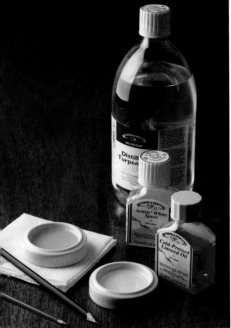

Solvents and oils can be used to change the characteristics of oil paint, and to clean brushes and equipment.

Solvents and oils

Solvents are used for thinning oil paint and cleaning brushes. I have used a low-odour brush cleaner (Sansodor) for many years now in preference to white spirit and distilled turpentine, as these have a strong odour and can leave a white residue when dry.

Cold-pressed linseed oil is a drying oil. It increases the gloss and transparency of a painting, reduces brush marks and speeds drying. For improving the flow of the paint, however, and smoothing brushwork, I prefer to use a ready-made mixture of solvent and linseed oil, otherwise known as a medium (see below).

Cleaning and storage

Thoroughly clean your brushes with brush cleaner (Sansodor) and kitchen paper or a lint-free rag. Wash the Sansodor out of the brushes with washing-up liquid, then rinse them thoroughly, dry and store upright, with the head uppermost, in a jar or other container. Shape any brushes that need it to a point. Do not forget to keep cleaning your brushes as you change colours while you work. This will avoid unnecessary transfer of colour and keep your work clean and bright.

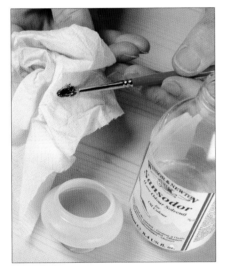

I use Sansodor, a low-odour brush cleaner, for cleaning my brushes.

Mediums

Mediums are mixtures of solvent and linseed oil that alter the handling characteristics of oil paint and reduce drying times. Liquin (also known as Original Liquin) is a quick-drying gel that, used sparingly, improves both the flow and transparency of the oil paint and smooths brushwork. It also acts as a thinner and as a great glazing medium. There are a variety of other oil painting mediums available as well as Liquin: Liquin Oleopasto will 'bulk up' your paint, making it ideal for impasto and texture work. It is also worth experimenting with Liquin Impasto and Liquin Light Gel as you progress, as these agents too may aid your technique.

1 Pick up a little Liquin with the tip of the brush.

2 Mix it into some paint on the palette.

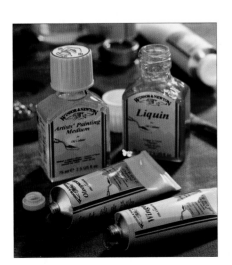

3 Mix in another colour if necessary to obtain the required colour.

4 Apply the thinned paint to the painting.

Liquin (also known as Original Liquin) is a highly versatile painting medium, which I have used for many years for thinning and glazes. It also speeds up the drying time of the paint.

Varnish

Matt varnish is an optional finish applied six months after a painting is completed. It gives the painting some added protection and can help even the colour resonance by dulling the oil shine and lifting areas of 'sink' or dullness. Apply thinly with a flat brush, using horizontal and vertical strokes.

Other materials and equipment

You will need a selection of soft, absorbent rags, kitchen paper and soft tissue for cleaning your brushes and lifting out excess paint (see page 45). Small pieces of natural sponge are useful for applying backgrounds (see page 45). You will also need one or two dippers – useful, inexpensive containers that clip on to the side of your palette and are used for holding mediums, oils and solvents during painting. Both metal and plastic dippers with screw-top caps are available. I have two dippers and keep brush cleaner in both of them, preferring to pour a small amount of Liquin directly on to the palette instead (see page 13).

For storing your brushes at home or in your studio, specially made brush vases are available, though any glass or plastic container will do. If you are travelling, use a brush roll to keep all your brushes together.

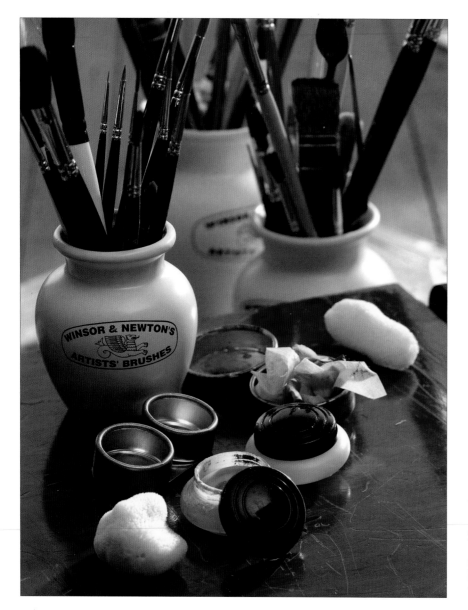

Matt varnish is my preferred choice to protect a painting because it is the closest to the original finish. Some painters may prefer a gloss or semi-gloss finish.

Take care not to overfill your dipper. If it unintentionally splashes on to your palette it will thin your paint. Natural sponges are great for creating unusual texture effects, but be prepared to throw them away as they can be difficult to clean.

Easels

The choice of easel is a very personal one. For studio work, the most important criterion is rigidity, whereas if you intend to work in the field, your easel needs to be lightweight and portable. I use a beech wood radial easel for my studio work which I have had for more than 25 years. For fieldwork and demonstrations I now use a lightweight aluminium easel. Whatever easel you choose, make sure the height and pitch adjust easily.

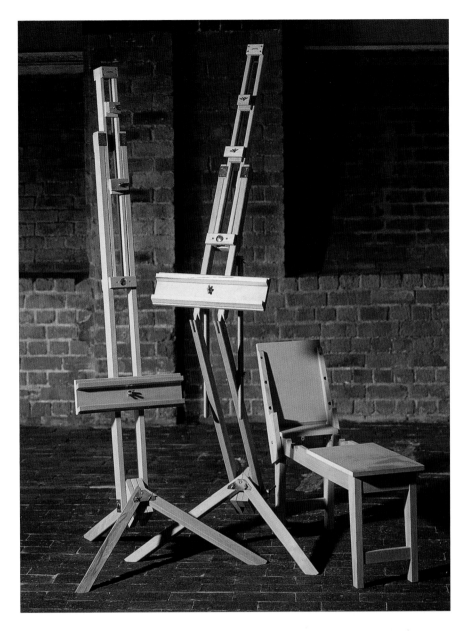

The radial easel is a studio workhorse. It is a good, steady platform on which to paint. The tilting radial easel (shown in the middle of the picture) has a central joint that allows the canvas to be secured in any position. On the right is a platform easel, which is both a bench and an easel combined, with a useful well for materials.

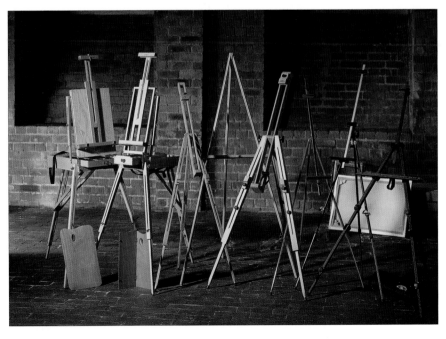

These sketching easels are lightweight and fold up easily, making them ideal if you need to transport your easel regularly, for example for painting outdoors. The two sketchbox easels, shown far left, fold down to a box shape making them easy to carry.

Composition

Composition is the most difficult aspect of painting to explain, but it really is the most important. If the composition, or design, of the painting is wrong, then adjusting everything else – use of colour, the tonal values or whatever – will not make the painting work. Luckily for landscape painters, there are some time-honoured approaches to help guide us.

Format

The shape of a canvas is either landscape or portrait (see below). It is best to start with the landscape format, because unless a simple study is required there can be a tendency to 'bunch up' the component elements of the landscape when using the portrait format.

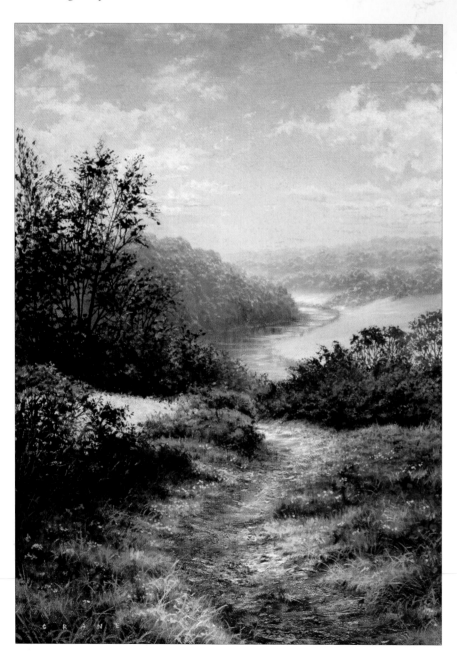

To the River
30.5 x 40.5cm (12 x 16in)

This canvas is painted in a portrait format to allow the river to be an extension of the path that leads to it. It allows for greater areas of both sky and foreground. The clouds add interest to the sky, but by painting them smaller and less distinct as they move towards the horizon they additionally serve as a mechanism for aerial perspective. The larger foreground area allows for the creation of further detail in the form of colourful wild flowers.

Open and closed landscapes

Structurally, I place landscapes into two broad categories: open landscapes and closed landscapes (see the pictures on the following page). An open landscape contains fields, plenty of sky, distant trees and some vertical elements. It is basically a scene with a view. It may need to contain other ingredients, such as buildings or animals, to add interest. A closed landscape is a composition with only a minimal, if any, distant view. Often it is a woodland painting. Such closed landscapes can offer marvellous opportunities for using pools of light and suggesting hidden places.

Most open landscapes will have similar elements. Working from the back to the front, these would be: a sky, a distant view, middle distance, foreground. The ratio of the sky to the ground depends entirely on the image we want to portray. It is sometimes suggested that dividing the picture into thirds, one-third sky and two-thirds ground or vice versa, should be the rule. It is generally thought that it is not a good idea to split the image in half – 50 per cent sky and 50 per cent ground. These are good rules to follow, but it is far more important that your design feels comfortable on the canvas, even if, spatially, it is incorrect. I usually go just over, or under, the centre line of the canvas – it works for me.

Dales
30.5 x 25.5cm (12 x 10in)

This is the more usual way for a canvas to be placed. It is called a landscape format. Generally speaking, it is how we see the world – in a horizontal panorama. This makes it easier to transfer what we see on to canvas.

Evening Flight
40.5 x 30.5cm (16 x 12in)

In this painting I have used the middle distance trees on the right and used the darker clouds above them to link the key elements (sky, distant view, middle distance and foreground). The rocks and reflections are used to generate foreground interest, with the stream leading you into the painting. In an open landscape such as this, the composition is spread out and not 'bunched up', which is what would happen if the whole scene were condensed into a vertical canvas. Try dividing the scene in half vertically with your hand to achieve two portrait-format scenes.

Tip

Compositions work better if the skyline or horizon is not a straight line but, depending on the distance, has at least a slight slope or irregular pattern.

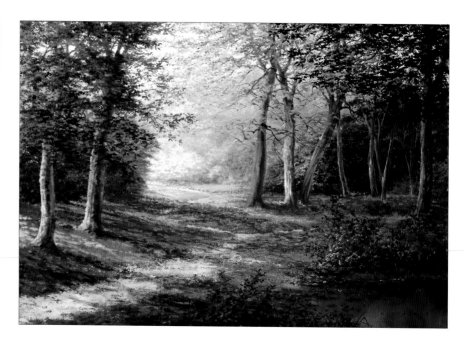

Autumn Gold
56 x 40.5cm (22 x 16in)

If a painting does not have a distinct horizon, for example a woodland scene, then I tend to call that type of composition a 'closed landscape'.
It presents an opportunity to draw the viewer into the painting, using a mechanism such as a path or stream, and framing the scene with tall trees on both sides.

Content and plane

Other aspects of composition for consideration are the content of an area and the plane of the ground. If a composition consists of two-thirds sky, then the sky will need to be more interesting and the plane of the ground, as it recedes towards the horizon, flatter (see Figure A opposite) than if the composition consisted of one-third sky. In the latter case the plane from the foreground to the horizon will be steeper (see Figure B). The addition of hills or mountains will mean that the slope of the plane finishes just before the hills or mountains (see Figure C). Again, these are only loose guidelines; it is far more important that your composition is pleasing to look at than that it obeys rigid rules.

On these pages I have described the main, structural aspects of the design of landscape paintings. There are many variations on these and it is great fun to try something different and unusual in a composition that will bring the viewer into the scene and tie all the fundamentals of the work together. On the following pages I will discuss the various component elements that can be included in a painting, and how they can be used to achieve different effects.

Component elements

It is usually desirable to include one main centre of interest in a landscape painting, with a path or a stream, for example, to lead the eye directly into it. It is also a good idea to include elements that will lead the viewer from the foreground into the distance in a natural way. Again, a meandering path or stream is the most obvious mechanism for doing this. The diagonals of the path or stream can be replaced or enhanced using complementary diagonals, such as hedgerows and fence posts, to further direct the eye into and around the painting.

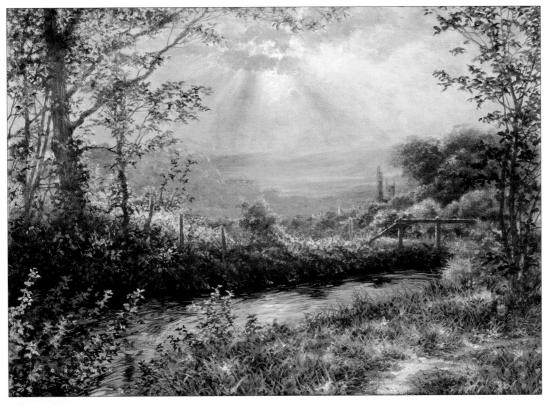

A Day to Remember
40.5 x 30.5cm (16 x 12in)

In this painting, the stream and fence posts direct you to the bridge, and the signpost points down the path.

19

A vertical structure to tie sections of the painting together will help give your composition balance. An obvious vertical is a tree trunk, which also provides an opportunity to frame the scene using the side branches (see below).

Once you have your basic design then you should consider other elements that will add further interest. These will be secondary points of interest for the eye to discover later, and may be buildings, animals, areas of light and dark, foreground foliage, and so on. One of my favourite devices is to give a painting an air of mystery by allowing a meandering path or stream to finish behind a tree or group of bushes, suggesting something beyond, just out of view.

The composition is the hardest part of painting to explain because it is the setting down on canvas of your ideas, and good ideas are personal and subjective. I have talked about aspects of composition and design which should serve as a good guide. Start, though, by simply sketching your ideas on to canvas and if you think it looks good it could be a masterpiece!

Tip

When painting a peat-based, shallow river where the water contains a lot of iron, as in the pictures shown here, if you add titanium white to raw sienna the result will have a slightly chalky look. A better, purer, effect can be obtained by slightly thinning the raw sienna with Liquin and using the white of the canvas.

Heron's Mead
76 x 51cm (30 x 20in)
The trees to the left of the painting and the corresponding shadow underneath have been used to join the top and lower halves of the painting, whilst the overhanging branches and dark foreground shadows frame the scene and focus the eye on the centre of the work.

Herriot Country
25.5 x 30.5cm (10 x 12in)

The tiny cottage in the middle distance of the painting was placed as a
secondary point of interest. I have added this because the small distant sheep
lack the contrast of the white of the cottage and take a little more finding.

Perspective

Many painters feel they do not understand perspective and 'switch off' whenever it is mentioned. Here I will attempt to explain perspective in simple terms that, hopefully, will clarify your perception of it.

Linear and aerial perspective

Perspective can be divided into two components: linear perspective and aerial perspective. Both are techniques for enhancing the three-dimensionality of a painting.

Linear perspective means that the horizontal and vertical planes within a painting will converge to a 'vanishing point' – usually on the horizon. If you were to draw an imaginary line from anywhere on the edge of the painting to your vanishing point, then any structural elements would need to follow these lines (see the diagram opposite). It is particularly important for architectural drawing and paintings containing many large buildings, such as street scenes. But again, luckily for landscape painters, we do not have to follow the rules too rigidly and can often use simple devices such as the narrowing of a stream or the diminishing size of fence posts to denote the effect of linear perspective.

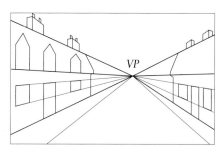

This diagram shows extended lines from the building converging to a vanishing point (VP) on the horizon, demonstrating linear perspective.

Aerial perspective is the other half of the perspective duo. It allows us to paint distant objects bluer and less distinctly. Tonal values are decreased as the atmosphere blurs all definition and blends distant horizons. This is a great tool, as it throws the foreground into even sharper focus. I will often lose part of the horizon just to give greater tonal strength to the foreground.

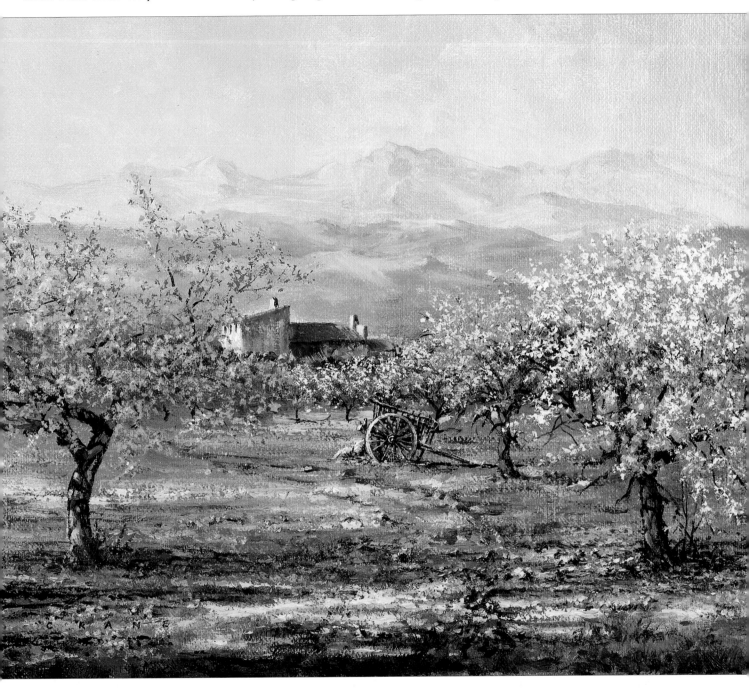

Almond Blossom *(above)*
30.5 x 25.5cm (12 x 10in)

The painting above demonstrates aerial perspective. The distant mountains, or sierras, appear blue and less distinct, whereas the foreground is sharper and more defined.

The Hamlet *(left)*
30.5 x 25.5cm (12 x 10in)

The cottages, fence posts and road all gravitate to a vanishing point in the centre of the painting, although often this would be on the distant horizon. This painting is a good demonstration of linear perspective.

Tip

I like working in detail using a fine brush and paints slightly thinned with Liquin, but detailed or 'tight' areas are best balanced with loose areas. This makes them more effective as too much detail can tire the eye.

23

Drawing

The ability to draw is usually associated with sketching with a pad and pencil, but equally important is to be able to handle a brush and paint with some degree of dexterity. I am a great advocate of the use of the camera for recording images that you can later incorporate into your paintings, but there is also a place for the tried-and-tested sketch pad, which forces close study and understanding of the subject. Equally important is the hand and eye coordination that regular drawing will nurture. This coordination will pass through into your brushwork, giving you greater confidence when you paint. Practise sketching and doodling whenever you can. No-one has to see the results if you do not want them to. Be patient – you will get better!

Sketching

Although these days I tend more and more to use the camera in place of my sketch pad, there is always a benefit to be had from sketching in the field. Only then can you get your 'feeling' of the landscape on to paper. It is also very important, especially during the early stages of your painting career, to develop the techniques of scale and perspective, tonal values and hand–eye coordination. Given a warm, sunny day it is a real pleasure, as well as a productive experience, to sketch outdoors.

I use a sketching pad with a relatively smooth finish. A fairly soft 2B pencil is the best for me for sketching, although I do occasionally use a 4B or 6B. This, a kneadable putty rubber and a can of fixative spray to prevent smudging are all the equipment I need for sketching. I will often add colour notes or other information that I think is pertinent to the scene for future reference.

As a personal preference, a hard-cover sketch pad better protects the work and gives a more solid surface.

Using the camera

The compact digital camera is an excellent tool and I often use it, as well as my SLR camera, to quickly capture and store images of clouds, puddles, views, trees and so on. Equally important is to capture the light: the way it hits the leaves, or strikes the trunk of a tree; the pools of light in a woodland, or shadows on a track. These are extremely useful pieces of information that I can retrieve and study at leisure later on. With the added use of a small home printer, I will often print sections of images, perhaps reversing the direction of the light, study these and fit them into my landscape painting when I need them.

Always use your own photographs, simply because you were there when they were taken, assessing the scene overall or seeking out specific reference material. The camera is merely recording this for you for later analysis. As you build up your photographic library you may be able to use specific images from several photographs and combine them together.

Below are two examples of paintings where I have taken photographs to capture the light and detail, and then adapted the photographs for a studio painting by formulating the composition I felt worked best.

In this painting I have shown that, if you wish, it is both possible and acceptable to produce a good painting almost exactly from a photograph.

Colour

So far I have talked about the elements that go into the design and composition of a painting, and have introduced important ideas that are relevant to the design, such as perspective and the ability to draw. Now is the time to bring the understanding and use of colour into the equation.

The colour wheel

To understand and take some of the mystery out of the subject it is as well to have a quick look at the colour wheel. The colour wheel is divided up around the three primary colours, that is colours that cannot be mixed from any other colour.

These are red, yellow and blue. The wheel is then broken into segments that graduate from one primary colour to another. These are the secondary colours. Colours that are opposite one another on the wheel are called complementary colours. It is that simple.

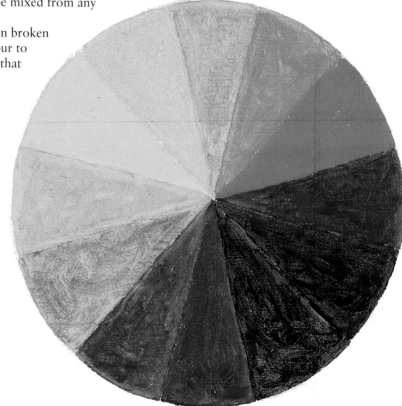

The basic colour wheel. It shows the simple graduation of the colour spectrum.

Mixing paint

Let us look at mixing colours. It is best to say at the start of this section that mixing more than three colours can lead to the mix becoming 'muddy' – a common complaint about oil paints. It is also difficult to get a repeat match of the original colour if it is mixed from more than three colours.

When mixing paints try to take a portion of one colour to an empty section of the palette and introduce the second colour to the edge of the first colour. This helps to keep mixed colours cleaner and unmuddied. Some colours, such as alizarin crimson, have a strong tinting ability; a small amount goes a long way and can overpower weaker colours. The gradual and gentle introduction of a second colour to a section of the first makes it easier to mix paints of different tinting strengths by avoiding the addition of too much of the stronger colour.

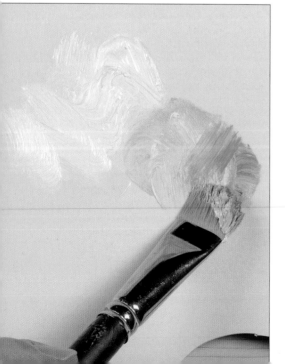

Mix two colours by gradually introducing one colour (in this case French ultramarine) to a section of the other (titanium white).

of a second colour to a section of the first makes it easier to mix paints of different tinting strengths by avoiding the addition of too much of the stronger colour.

Mixing three colours

When mixing three colours, the same procedure applies as when you are mixing two. When I am mixing a purple or pink colour, for example, I will take some titanium white from that already squeezed out on my palette and spread it out a little on an empty part of my palette. I will then introduce a hint of French ultramarine at one edge of the white, followed by a touch of alizarin crimson. By introducing a little of each colour gradually, I keep control of the mix until I get the desired purple or pink. Keeping control when mixing colours is very important. A common cause of dissatisfaction when trying to mix oil colours is a lack of awareness of the strengths of the different pigments. It is very disappointing when the great versatility of oil paint is underestimated or dismissed through a lack of primary instruction and the result is a 'muddy mess'!

Mixing greens

One of the stimulating challenges that a lot of landscape painters will encounter is that in many countries in the world the landscape is green. Green is an awkward colour in some respects. If certain landscapes are painted accurately they may look too green and this jars the senses. Therefore, the amount of green in the painting has to be reduced or altered to make it more interesting. I use terre verte (earth green) as my base green, and I will usually add yellow ochre, burnt umber or a blue to vary it. Green can also be mixed simply using lemon yellow and cerulean blue, for example. Even lamp black and yellow will make a green.

It can be great fun trying to find a green to suit the mood of your painting. Subtly place other colours in your green, such as pink or Naples yellow, and you will be amazed at the result. Do not forget aerial perspective as well. The further away towards the horizon the section of painting is, the bluer the green should be. In the foreground, try adding some sap green, burnt umber or French ultramarine to sharpen up the tonal values.

Mixing earth colours

Some of the earth colours can be added to blues and greens very effectively, and quite subtly change the emphasis of the resultant colour. If a little bit of burnt umber is added to cerulean blue and titanium white it will slightly deaden the blue to give a muted sky. If more burnt umber is added to the mix it will produce a lovely silvery colour.

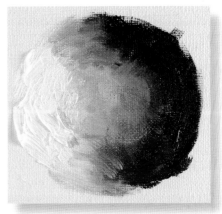

Mixing different amounts of French ultramarine, burnt umber and titanium white results in a range of useful colours that can be used, for example, for tree trunks, snow and thatched roofs.

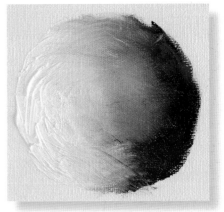

Replace the burn umber with alizarin crimson for an array of pinks and purples, which I use for skies and distant mountains. Vary the amount of each colour to get a pinker or more purple mix. Add white to lighten.

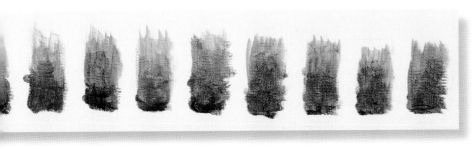

These mixes show the range of greens that can be mixed from a fairly narrow palette. The sample on the far left is terre verte thinned with a little Liquin. The subsequent mixes (from left to right) consist of terre verte and cerulean blue, French ultramarine, yellow ochre, raw sienna, burnt sienna, burnt umber, Vandyke brown and olive green.

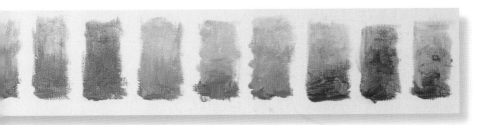

From left to right, these mixes are yellow ochre thinned with Liquin, then mixed with cadmium scarlet, cadmium red, Naples yellow, lemon yellow, and cadmium yellow; raw sienna thinned with Liquin, then mixed with cadmium red, and lastly cadmium yellow.

Colour temperature

Colours are often defined as having a 'temperature'. A painting may be described as 'hot' if it has a lot of reds and yellows in it, or 'cool' if the overall colour theme is more towards blue or the paler greens. This reflects our perception of red as exciting, oranges and earth colours as warm and, as blues and greens become paler, they seem cooler. This is something that we can use to great effect in our painting. An autumnal landscape with browns, oranges and yellows can have a lovely warm glow. Alternatively, the autumnal Maple and Aspen trees of North America can be countered by a pure blue sky or warmed by a yellow one.

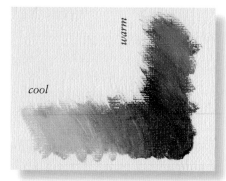

Green is a relatively cool colour. The addition of a lighter colour, in this case white, cools it further; adding a warmer colour, such as cadmium yellow, warms it up.

Here, French ultramarine has been cooled using cerulean blue, white and Naples yellow, and warmed up using alizarin crimson and, finally, cadmium scarlet – a hot red.

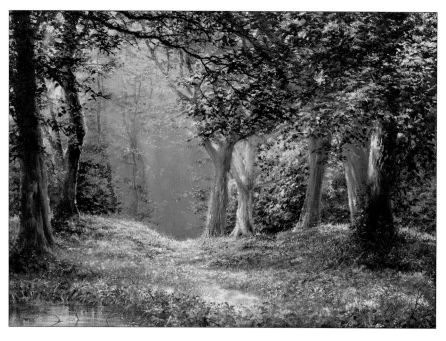

The Clearing
40.5 x 30.5cm (16 x 12in)
This is a good example of using cooler colours to achieve the atmosphere one would come across when emerging into a clearing deep in the woods.

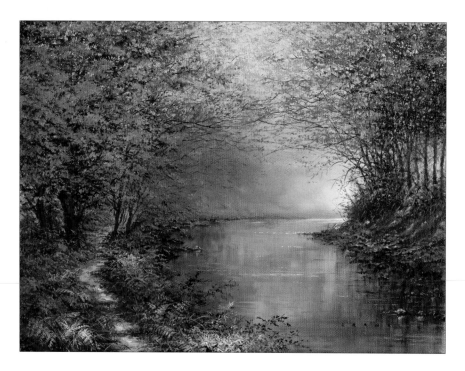

Autumn Hues
40.5 x 30.5cm (16 x 12in)
A good example of a warm painting using browns and pinks, and working up to hot reds.

Cotswold Walk
40.5 x 30.5cm (16 x 12in)
The painting on the right uses cool colours overall, but the addition of hotter colours – the brown trees and pink cloud, plus the red poppies – balances the overall coolness of the painting.

Addition of colour for interest

Another attribute of colour is that we can use it, without giving it form, to add interest to an element or section of a painting. Green fields, for example, can be enhanced by the subtle addition of other colours that are not normally associated with these areas or passages – little amounts of flesh pink, purple, yellow, or even little flecks of pure cerulean blue can be used to add interest. The additional colour should be applied with great care. If heavier applications of a different colour are necessary, then it will need to be given some form, such as wild flowers.

The careful addition of pinks and purples to many landscape elements – snow, water, paths, tree trunks – has the dual purpose of giving warmth as well as interest. A bluish purple mix, hidden in grassy areas, can give your work extra body as well as muting the cooler greens. These are subtle, often hidden facets of colour.

For a landscape painter, an area where large passages of warm colour can be used to great effect is in the sky. Sunsets and sunrises are a wonderful opportunity to set the mood of a painting using the warmer colours. It is, of course, best to let any blue in a sky dry before adding yellow, but purples and pinks can be added at any time.

Another fascinating way we can use colour in a painting is to experiment with complementary colours, that is, the colours that are opposite each other on the colour wheel. A large passage of a green field can be enhanced by introducing some dots of red poppies, red being the complementary colour to green. The earth colours of a Mediterranean landscape can be 'woken up' by the addition of a cerulean blue cart. If used with discretion, the effects can be very eye-catching.

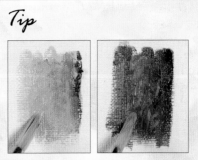

Tip

A thin glaze of pink, purple or blue is an understated but clever way of enhancing an element in a landscape such as a near foreground tree trunk. It may not seem much on its own, but little touches like this add up to a more comprehensive painting.

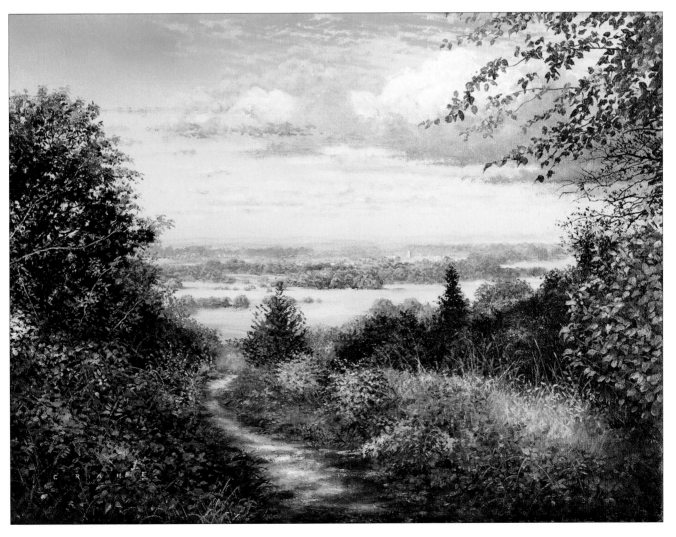

Tonal values

The tonal values combine with the perspective of a painting to give it depth. The simplest demonstration of this is a sphere with an imaginary light source coming from the left, as in the diagrams below. This simple device can be used to great effect in a landscape and it is important to properly exploit the full tonal range, including the addition of shadow, if the work is to look strong and three-dimensional.

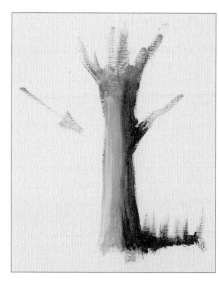

In the sketch above, the light is coming from the top left of the picture. I have painted the trunk using a mid-tone yellow ochre, then added Naples yellow – a lighter tone – on the left and burnt umber, which is darker, on the right. I have then placed a white highlight down the left-hand edge, and pulled out the shadow to the right to 'bed' the trunk in.

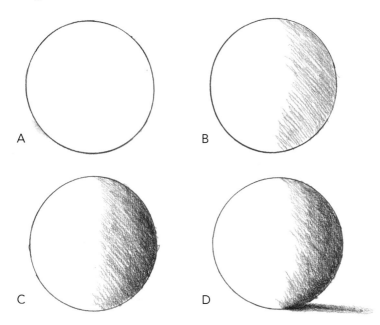

Sphere A appears as an empty circle. If we add some shading, as in B, it is now starting to look more like a round ball. This is called a 'half tone', but it still requires additional shading (C) to give the appearance of a fully rounded sphere or ball. It now has the full tonal range. The addition of a shadow (D) sits the sphere on to a surface, completing the three-dimensional illusion.

Using light

In one sense, light is directly related to tonal values. Without a light source there would be no shadows and hence no tonal values to give a three-dimensional quality to the painting. The lack of a small but essential amount of the final deep tonal value is one of the reasons a piece of work can look washed out and flat. The shadow element is also key to seating objects into a painting, and will help to bind the work together. Before adding highlights to a painting, it is worth looking at the darkest tonal values, as increasing these may mean that less highlight is required. If a painting has too many highlights, they can lose their effectiveness.

Try to make sure that your light source comes from a single point, either outside the picture or, as would be the case in an early evening sunset for example, within it. The portrayal of the light source in the latter case will set the mood of the painting. If I am painting a closed landscape, such as a woodland scene, I will often disguise the source of light, suggesting that it comes from a particular direction off the canvas. This gives me more freedom to highlight leaves or branches and to introduce pools of light on the woodland floor where it suits the composition best. Do not be afraid also to use secondary light sources such as street lamps or windows.

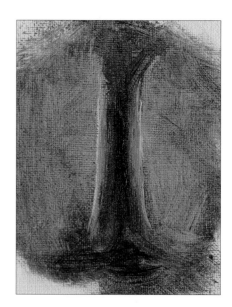

It can be great fun to use light to either backlight, or silhouette, subjects such as trees. Again this approach is more suited to a closed landscape. This effect was achieved with a darkish background and a light source coming from behind, outlining the tree trunk with a light colour such as Naples yellow.

To create mood or atmosphere, I will often build a painting around shafts of light entering woodland clearings. It can also be a very effective approach if top lighting is suggested instead. It needs a little mental planning, but it is very rewarding when it works.

Contrasts

In the same way that we can play complementary colours off against each other, we can juxtapose areas of light and dark to great effect: a dark bundle of leaves against a much lighter background will stand out dramatically.

Dark against light.

Light against dark.

Here I have used soft colours and a hidden light source to create atmosphere.

Shadows

Shadows are a key component of a landscape painting. They can be used to show the shape of the ground, delineating the bumps and hollows, or the slope of a surface. They anchor a component element to the ground.

Shadows are at their darkest where they join the parent object, and the further away something is in the plane of the painting, the lighter and less defined will be its shadow. Conversely, shadows that are closest to the front of the painting will be sharper.

A shadow will have a darker value than the surrounding area, but it can be an opportunity to add interest by the subtle addition of some other colour into the area of shadow. Do not forget to blur and soften the edges of shadows as they move away from you.

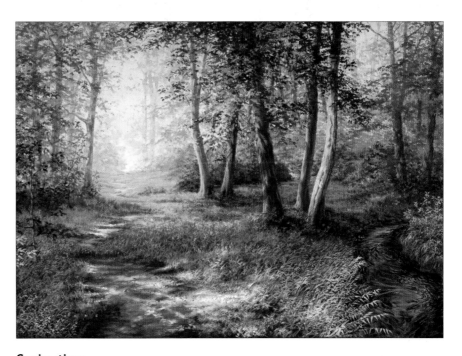

Springtime
56 x 40.5cm (22 x 16in)

I love painting woodland scenes like this, in which the sunlight and shadows evolve as the painting progresses. The foreground sunlight attracts your attention, then the path takes you into the painting. The stream adds a good secondary point of interest for the eye to explore.

Demonstrations

For the following three demonstration paintings I have chosen distinctly different landscapes. This is to guide you through both open and closed landscapes, and a good range of colours. The cooler winter landscape is different in its colour spectrum from the hotter Mediterranean scene. The 'Woodland Path' is another interesting challenge – although the composition is relatively simple, care should be taken with the mass of foliage, which requires a little skill to master. All of the techniques used in the projects are explained elsewhere in the book, and I have included tips where necessary to explain the methods more clearly.

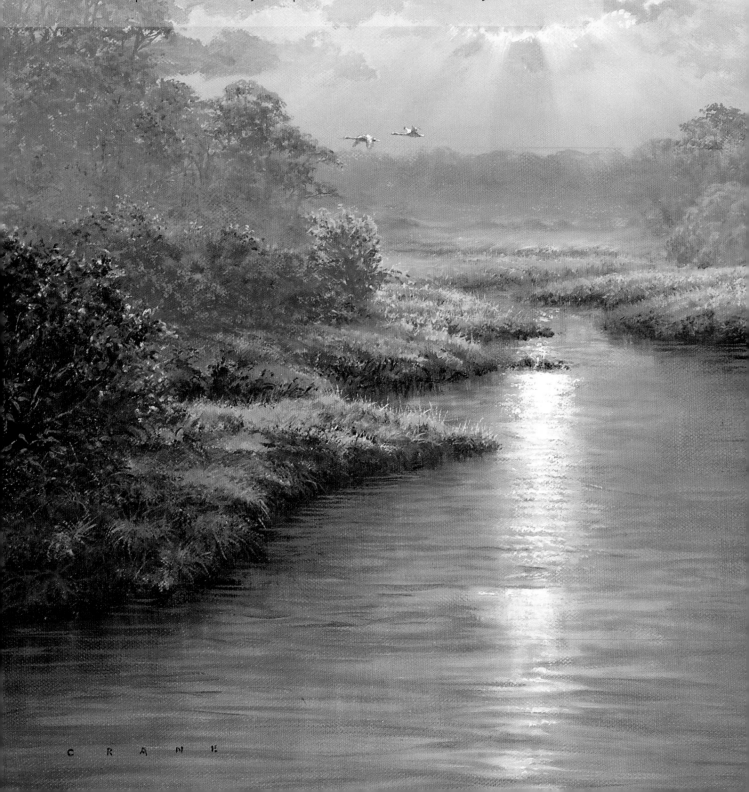

CRANE

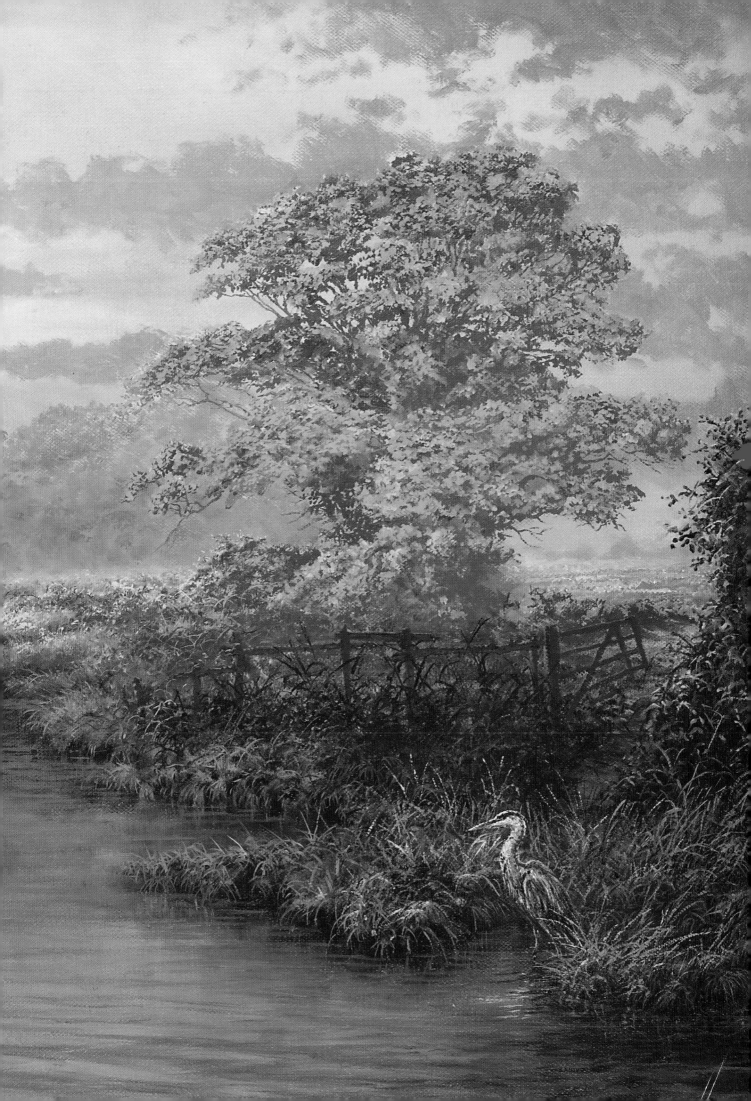

Winter Stream

In this project I hope to take you from a blank canvas to a mellow and gentle snowy landscape. Try to keep your colours clean. White paint will pick up any other colour quite easily and so it is important to be a little wary with its application. Do not forget that blue and yellow mixed together will make green so let your sky dry before you add the yellow, or at least cover the blue with a wash of purple. The highlights that are added at the end will bring your painting to life, so have a good time and enjoy it.

You will need

Stretched linen canvas, 30 x 25cm (11¾ x 9¾in) (alternatively, use cotton canvas or canvas board)

Paintbrushes: fairly stiff size 12 flat; size 2 flat/bright; 19mm (¾in) mop; old, stiff brush for stippling (see page 11) or small goat hair mop; soft sizes 0 and 2 sable/synthetic rounds; fairly stiff size 2 general-purpose round; half rigger or size 0 lettering brush

Palette

Liquin, brush cleaner (e.g. Sansodor)

Kitchen paper

Colours: titanium white, French ultramarine, alizarin crimson, cadmium yellow, lemon yellow, Vandyke brown, burnt umber, cadmium scarlet, Naples yellow, burnt sienna

1 Make a medium intensity mix of light blue using titanium white and French ultramarine thinned with a touch of Liquin and lay it on to the top part of the canvas using the size 12 flat brush. Fade the colour out towards the horizon. Paint in a rough horizon line, then blend in some neat white from the horizon line upwards. Map in the stream.

2 Use the same colour to block in the area below the horizon, either side of the stream. Bring a little alizarin crimson into the mix and lay it on just above the horizon, blending it upwards into the blue. Use the same colour to underpaint the stream.

Tip
When painting a river or stream, always work only in horizontal and vertical brush strokes, as this gives a good background for building up reflections and ripples.

3 Darken the sides of the stream slightly, then use the mop brush to move the paint around and get rid of the brush marks. Lose any white that is showing through and allow to dry.

4 Bring in a little more alizarin crimson and a touch of French ultramarine to make a pinker mix. Using the size 12 flat brush, gently pull the glaze across the sky in sweeping bands. Avoid the central area, which will eventually be yellow. Use the mop brush to blend in the colour.

5 Change to the size 2 flat/bright brush. Make a mix of cadmium yellow and titanium white. Mentally position the sun over the stream so that some of the reflection from it will strike the right-hand riverbank, then work the colour outwards from the sun using horizontal brush strokes. Place a pale yellow close to the sun, and darken it as it gets further away. Paint a yellow band across the sky below the sun, and add some yellow streaks higher up too.

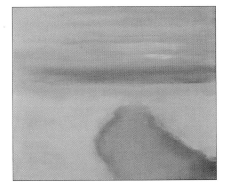

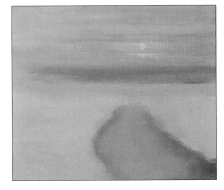

6 Darken the lower section of the sky using a mix of alizarin crimson and French ultramarine, then introduce a little cadmium yellow to the mix to form a dusky purple and apply it over the top. Blend it into the yellow with the mop brush. Bring some lemon yellow into the area closest to the sun, and add touches of the same colour here and there to the top part of the sky.

7 Paint in the sun using a dot of pure titanium white. Alter the strength of the yellow around the sun in order to obtain an even gradation of light. Use the size 2 flat/bright brush to add some white highlights to the clouds closest to the sun. Blend the paint if necessary using the mop brush and allow to dry.

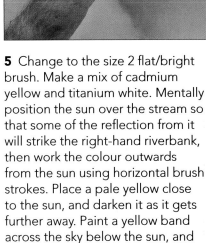

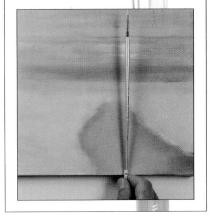

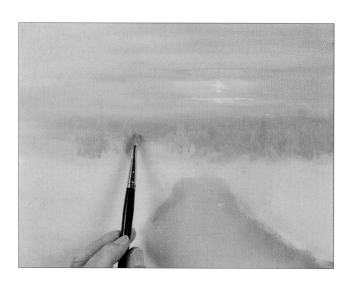

8 Add a little more French ultramarine to the mix to darken it and use the stippling brush to put in the trees in the background. Use a fairly dry mix and apply the paint by dabbing it on with the side of the brush. Focus on the trees in the central area, as those either side will be hidden behind the foreground trees. Blend the base of the trees into the background.

Tip

The use of the bluer mix for the background trees will recede them and give the painting aerial perspective.

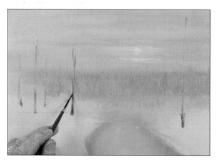

9 Extend the base of the background trees down to the stream. Map in the foreground trees using a dark grey mix of French ultramarine, Vandyke brown and a little white applied with the tip of a soft size 2 round brush. Place a single brush stroke where the central trunk of each tree will be.

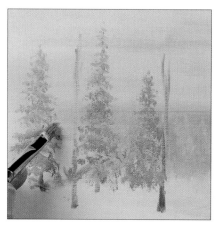

10 For the three trees that sit behind the foreground trees on the left, make a paler blue-grey mix and use the stippling brush to dab on the foliage in lines to mimic the branches (see page 11). Use the tip of the soft size 2 round brush to sharpen the edges of the branches. Allow the paint to dry.

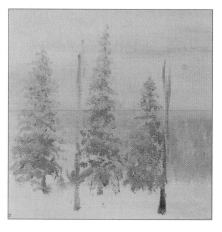

11 Use French ultramarine and titanium white to make a blue-grey mix, and with the soft size 2 round brush dab snow on to the tops of the branches. Allow the paint to dry.

Tip

Study pictures and photographs of snow-covered trees to familiarise yourself with the way the snow lies on the branches and foliage.

12 Darken the dark grey mix by adding more brown and French ultramarine, and dab on the foliage of the foreground trees using the same technique as in step 10. Apply the finer detail at the ends of the branches and the top of the tree using the tip of the soft size 2 round brush. Take the top of the right-hand tree off the edge of the canvas.

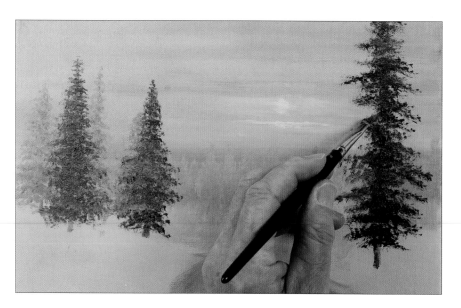

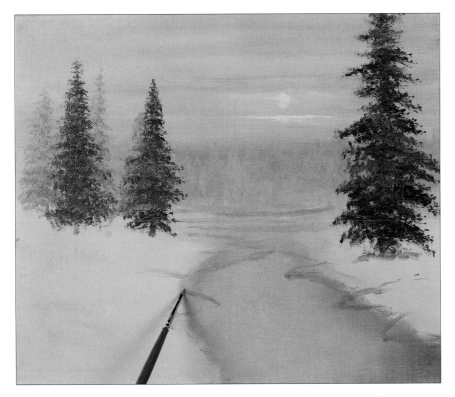

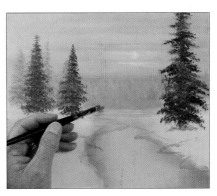

14 Using the size 2 flat/bright brush, darken the area beneath the distant trees using a mix of French ultramarine and white. Use a stronger mix to introduce some darker trees into the background. With the stippling brush, delicately dab some pink on to the area, then use the soft size 2 round brush to place some touches of white below the sun where the light bounces off the snow.

13 Complete the main tree, emphasising the downward curve of the branches as they are weighed down by the snow. Start to shape the curves of the riverbank using the soft size 2 round brush and a mix of white and French ultramarine. Map in the stream as it zigzags into the distance, and the contours of the land either side of the stream and below the distant trees.

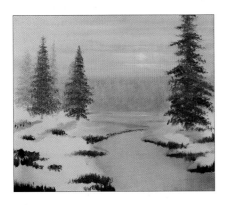

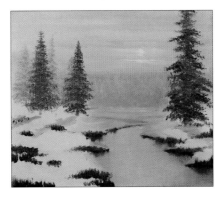

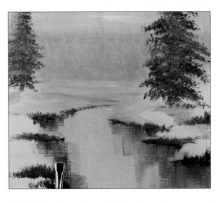

15 Start to add structure and shape to the foreground. Begin by mapping in the shadows of the trees using a mix of French ultramarine and white applied with a size 2 general-purpose round brush. Change to the stippling brush and mix some burnt umber into the dark grey mix from step 12. Dab in the grasses, placing them randomly to achieve balance and guide the eye into the picture. Use the same mix to put in the riverbank just below the edge of the snow.

16 Clean the brush on some kitchen paper and drag the paint from the clumps of grasses at the edge of the stream down into the water to create reflections. Take the mop and gently brush across the reflections from side to side to blend them into the water. Strengthen the clumps nearest the foreground by dabbing more paint into them and repeating the process.

17 Use the size 12 flat brush to darken and strengthen the sides of the stream. Make a mix of alizarin crimson and French ultramarine, and apply the paint with vertical brush strokes, starting at the edge of the stream and dragging the paint down. Add in some subtle patches of alizarin crimson using the same technique.

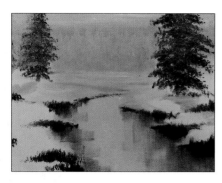
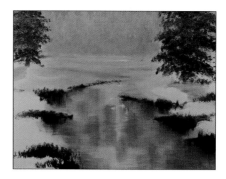
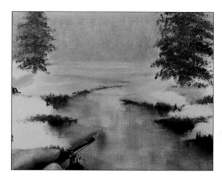

18 Use the stippling brush and Vandyke brown to further strengthen the grasses at the water's edge, blending the lower part into the water. With the size 12 flat brush, pick up a little of the pink mix and drag it across the stream. Blend it in with the mop brush, again using only horizontal and vertical strokes.

19 With vertical strokes of the same brush, bring some cadmium yellow into the stream, directly underneath the sun. Add a little cadmium scarlet to the yellow to make a bright orange and lay it either side of the yellow using light brush strokes. Blend the colours together by brushing from side to side with the mop.

20 Mute down the brighter colours by dragging a pale pink mix across them using the stippling brush. Gently put some pink into the remainder of the stream to give it more colour and interest. Vary the shade by adding different amounts of alizarin crimson to the pink mix.

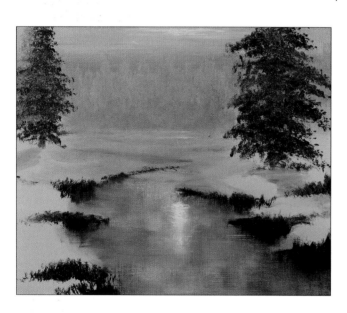

21 Mix some clean white paint with a little cadmium yellow and use the stippling brush to lay a bright reflection directly underneath the sun. Blend it in at the edges using horizontal brush strokes. Repeat the process using lemon yellow. Change to the soft size 2 round brush and place small dots of titanium white down the centre of the sun's reflection. Blend them in by dragging the brush through them using vertical and horizontal strokes. Lay on another layer of white thickly to strengthen, creating an impasto effect (see page 57).

Tip
Remember to use only horizontal and vertical brush strokes when painting the stream.

22 Repeat step 21 at the top of the stream using a soft size 0 round brush. Add more blue (French ultramarine and white mix) on either side of the sun's reflection using the flat edge of the size 2 flat/bright brush, and pull out some of the yellow and white from the reflection and blend it into the rest of the stream. Build up the white highlights as before. Continue developing your painting in this way until you are happy with the result. Leave it to dry.

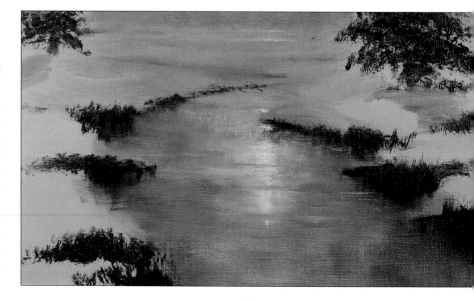

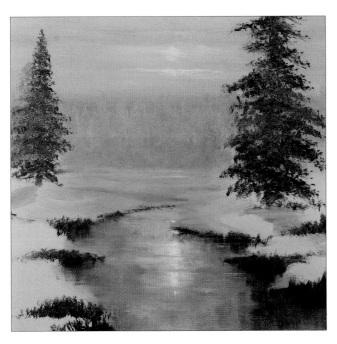

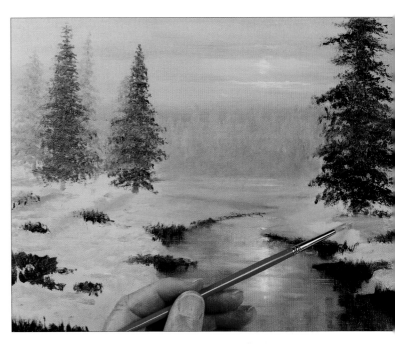

23 Using the size 2 general-purpose round brush, place a strong, dark brown reflection in the stream underneath the main tree on the right. Blend it in with the mop brush. Overlay the reflection with a purple mix of French ultramarine and alizarin crimson. Mix together some Naples yellow, cadmium scarlet and white and gently use it to put more colour into the stream.

24 Add some touches of pink, mixed from alizarin crimson and white, to the snow either side of the stream. Dab it on in patches using the side of the brush. Lay the pink partly over the shadows to meld these two elements together.

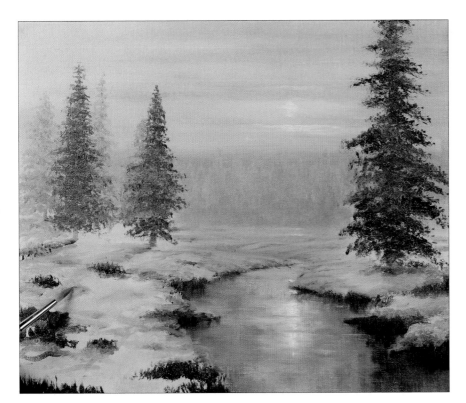

25 Blend in the pink with your fingers, clean the brush then introduce some French ultramarine to the snow-covered foreground, in-between the areas of pink. Place it in the shadows to emphasise the unevenness of the land, and in the darker areas beneath the trees and grasses. Also put a hint of blue within the clumps of grass to help unify the area. Use the same blue to add stronger shadows to the area of mid ground below the line of distant trees, and to define the path of the stream as it disappears round to the left.

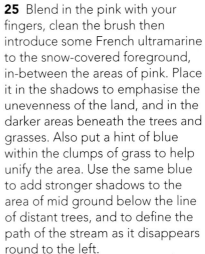

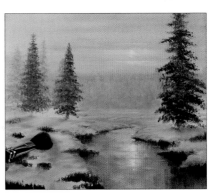

26 Gently blend in the blue using the mop brush.

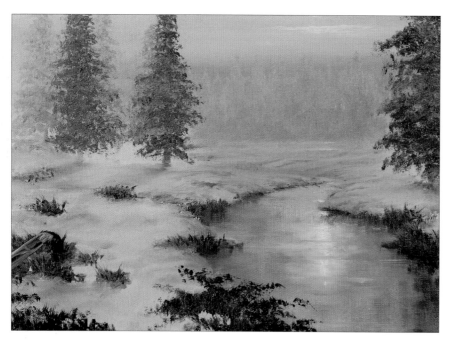

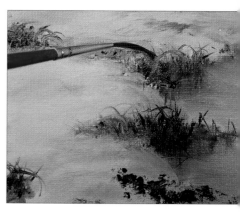

27 Using the stippling brush, strengthen the grasses in the foreground by gently dabbing on some burnt umber. Add detail by putting in some blades of grass by flicking the paintbrush upwards.

28 Change to the half rigger (or lettering brush) and use it to further define the clumps of grass. Pick up a tiny amount of paint and use small, random brushstrokes to put in individual blades. Bend the tops of the grasses over at different angles to give them a wild, untidy appearance.

29 Using a dark grey mix, put in some undergrowth at the base of the foreground trees. Add some lighter blades of grass to the dark brown clumps using a mix of burnt sienna and white, then put in some snow-covered ones using French ultramarine and white. Here, I have used a trimmed size 1 brush (see page 10), but the lettering brush will do just as well.

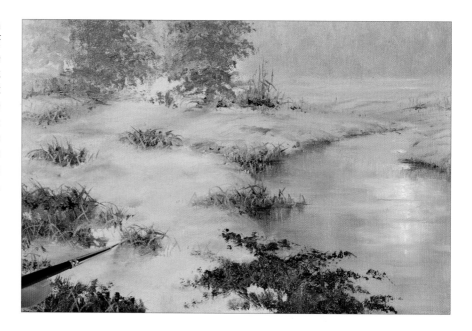

Tip

To build up an area of grass you will need a long, thin brush with a good point, for example a half rigger. Paint in the blades of grass using short, upward brushstrokes, starting with the darkest tones and lightening the colour as the painting progresses.

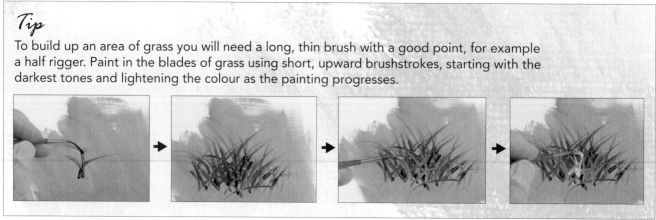

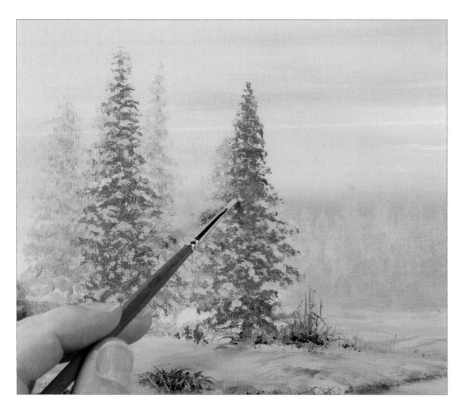

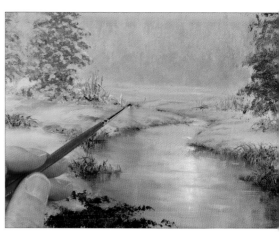

31 Develop the undergrowth to the right of the left-hand trees (see steps 29 and 30). This will create a clear division between the foreground and the background. Use a deeper blue mix and the soft size 2 round brush to accentuate the shadows where the stream curves round to the left. Extend the sun's reflection into the uppermost part of the stream using pale pink with a little yellow placed on top, followed by a touch of white.

30 Use the soft size 2 round brush to place the snow on the foreground trees. Make a very pale mix of French ultramarine, white and a touch of burnt umber that is slightly stronger than the snow on the trees behind, and dab it randomly on to the tops of the branches. Curve the branches downwards at the ends, as if weighed down by the snow. With the same mix, put in some snow-covered grass stems within the undergrowth beneath the trees using the half rigger.

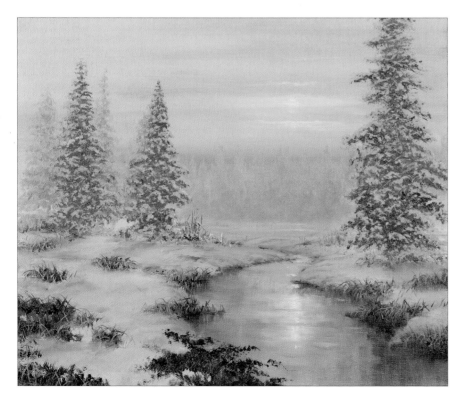

Tip

A more closed landscape can be created by placing barriers between the foreground and the background. This enhances the sense of mystery, leaving the viewer wondering, 'What lies beyond?'.

32 Using a slightly bluer mix than that used in step 30, add snow to the right-hand tree; the stronger tonal value will bring the tree forwards into the foreground. Continue to strengthen the undergrowth beneath the left-hand trees using the half rigger, and with the same brush add some finer branches here and there to further define the trees.

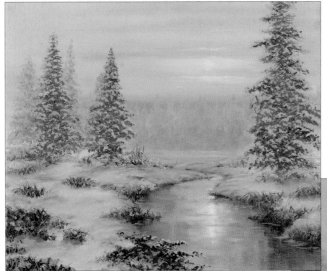

33 Mix a slightly darker blue and put snow on to the clumps of grasses in the foreground using the soft size 2 round brush. Lay the snow on the tops of the stems to create a realistic effect. With the same mix, place some blue into the water at the sides of the stream to give it emphasis – use short, horizontal strokes extending from the riverbank.

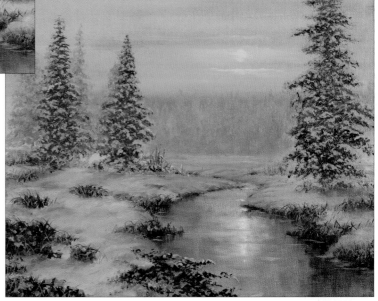

34 Strengthen the darkest shadows on the ground, under the clumps of grass, using a weak dark blue mix. Strengthen the pink here and there too, blending both colours into the background, avoiding hard edges.

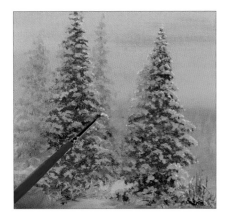

35 Using the soft size 0 round brush, dot in the highlights on the trees using pure titanium white. Place them where the sunlight will strike the trees, on the tops of the outer branches.

Tip
Avoid over-stating the highlights – if there are too many they will lose their impact.

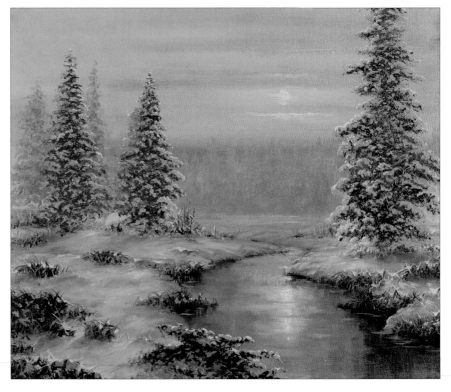

36 Continue placing highlights on the trees, and on the grasses and undergrowth on the ground. Change to the half rigger for the finer highlights on the blades of grass.

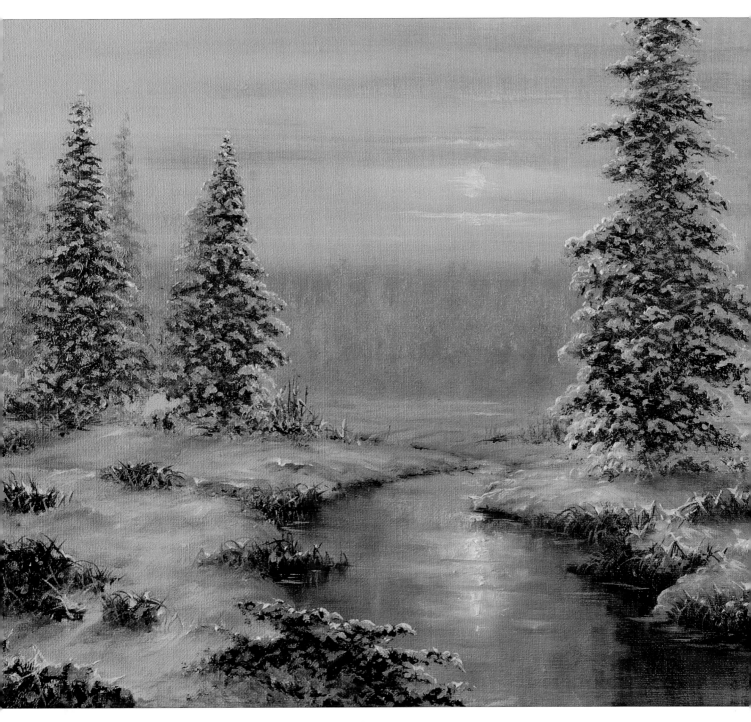

When you have completed your painting, stand back and look at it as a whole. Deepen any tonal values and add highlights where you think they may add value.

Woodland Path

This is a different type of landscape from 'Winter Stream'. More of the painting is suggested by using tonal values and colour rather than by line. The only lines are the trees and branches. Once again, the application of the paint must be done with care to avoid the foliage becoming messy. However, do not be daunted by it – it is easier to achieve a good result than you might think.

Woodlands are one of my favourite types of landscape to paint, because you can add so much interest and drama to them in the form of little pathways leading off to some mysterious place and lovely passages of sunlight and dark shadows.

You will need

Stretched linen canvas, 30 x 25cm (11¾ x 9¾in) (alternatively, use cotton canvas or canvas board)

Paintbrushes: fairly stiff size 12 flat; 19mm (¾in) mop; old, stiff brush for stippling (see page 11) or small goat hair mop; soft sizes 0 and 2 sable/synthetic rounds; fairly stiff size 2 general-purpose round; half rigger or size 0 lettering brush

Palette

Liquin, brush cleaner (e.g. Sansodor)

Kitchen paper and soft tissue

Colours: French ultramarine, titanium white, Naples yellow, raw sienna, terre verte, burnt umber, burnt sienna, Vandyke brown, olive green, lemon yellow, cadmium yellow, cerulean blue, yellow ochre, alizarin crimson, cadmium red

1 Make a light blue mix of French ultramarine and titanium white and paint in the sky, taking the colour approximately two-fifths of the way down the canvas. Use the size 12 flat brush and lay on the colour evenly. Blend in the brush marks using the mop brush. Change to a fairly stiff size 2 general-purpose round brush and map in the main trunks and the path using Naples yellow thinned with a little Liquin.

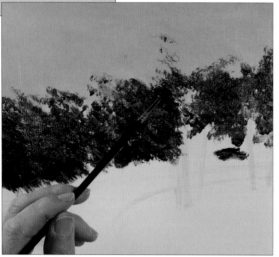

2 With the stippling brush, block in the foliage using a mix of raw sienna and terre verte. By firmly dabbing on the paint randomly, you will create an irregular, mottled background resembling dense foliage. Refer to the finished painting as you work, and vary the mix to obtain areas of relative light and shadow; in the darkest areas, mix in a little French ultramarine. There is no need to avoid the trunks – these serve as a memory aid only.

Tip

Remember to always clean your brush before changing to a new colour. When using a mop brush to blend different coloured areas, clean it regularly to avoid tranferring too much paint from one area to another.

Tip

Continue to add in tiny amounts of Liquin to your mix every now and then – just touch the edge of the brush with the Liquin – as this helps thin the paint, aids fluidity and reduces drying time.

1 Create a coloured background by painting on areas of colour using a large, general-purpose wash brush.

2 Move the paint around and blend the colours together using a mop brush.

3 Alternatively, blend the colours together and lift out the excess paint using a cloth lightly soaked in Sansodor. The result is a soft, muted background that is not achievable with a brush.

4 Dip a sponge in Liquin and dab it on to the background for an interesting, mottled effect.

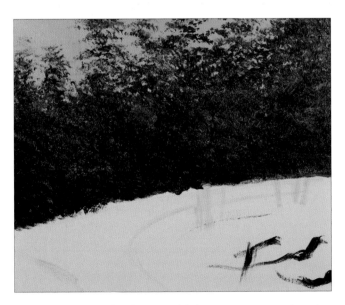

3 Complete the background foliage, creating a border around the far edge of the path. Leave gaps in the upper parts of the foliage where the sky is visible, and make it denser and darker towards the base.

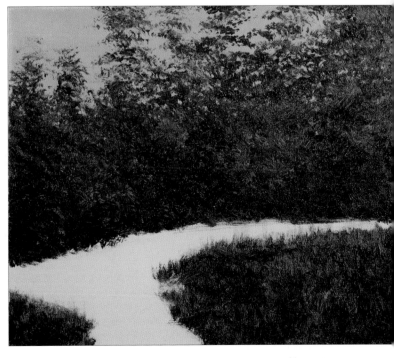

4 Using the same brush, lay in the areas of ground either side of the path in the lower part of the picture. Use short, vertical brush strokes to resemble grass. Darken the shaded areas using burnt umber, and introduce a little burnt sienna for added interest.

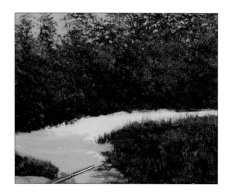

Tip

As well as using heavier tonal values, use impasto on paths, tracks and areas of bare ground as you progress towards the front of a landscape. The resulting texture gives real depth to your painting.

5 Lay a base of Naples yellow over the path, without thinning the paint with Liquin (this gives the paint more texture). Use horizontal strokes of the size 2 general-purpose round brush. Bring in a little raw sienna at the sides for shadows.

6 Once the base colour has been laid, introduce some patches of Vandyke brown at the edges of the path to darken it further. Leave fairly distinct brush marks and use impasto (see page 57) to create texture.

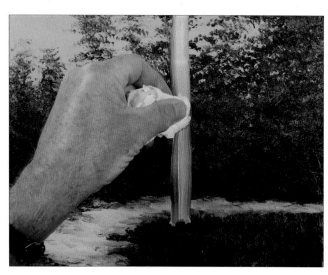

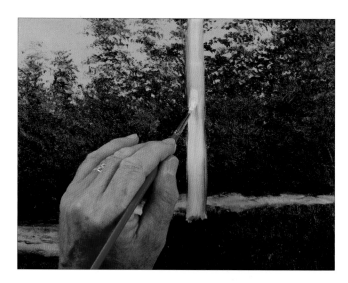

7 Using a mix of Naples yellow and white, paint in the main tree trunk in the middle of the picture, then remove the paint by lifting it out with a soft tissue (see below), as it will have picked up a lot of green from the background.

8 Paint in the tree trunk again using the same mix.

Tip

If you want an area or piece of work to be reduced but still quite visible, excess paint can be removed by placing a soft tissue over it and pressing gently, a little like using blotting paper. This will pull off some of the weight of paint. It is a technique I sometimes use for middle distance or distant trees, as in this demonstration.

1 The painted area that requires reducing.

2 Blot the area with a piece of soft tissue paper.

3 Lift off the excess paint, leaving a reduced image on the canvas.

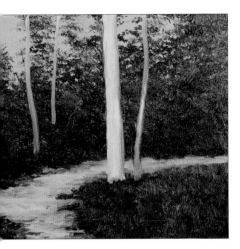

9 Map in the rest of the main tree trunks using the same technique (steps 7 and 8).

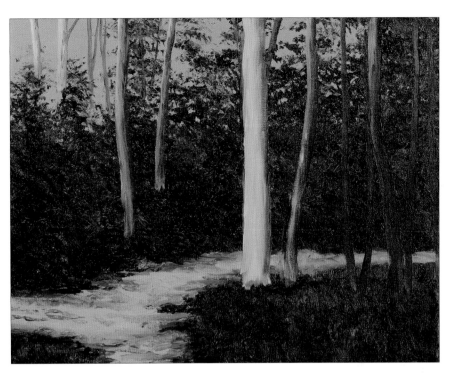

Tip

Excess paint can also be removed using Sansodor. Brush on the solvent, then clean the brush, squeeze it dry and use it to remove the Sansodor. The area can then be painted. This is a useful method to use on smaller areas where a tissue would be difficult to use.

10 With a mix of olive green and raw sienna, place a shadow down the right-hand side of each of the main trunks and colour the smaller, more distant trees. Use variations of the same mix, sometimes with a hint of burnt sienna added, to strengthen the colour of the darker trunks and blend the colour into the shadow down the right-hand side. For the darkest tree trunks on the right, use a mix of burnt umber, burnt sienna and a little Naples yellow. Leave the painting to dry.

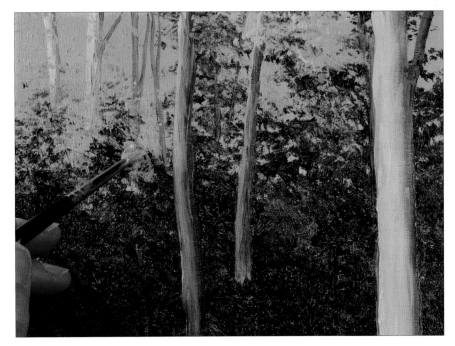

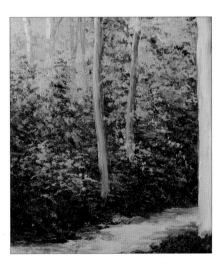

12 Darken the mix slightly for the mid-tone greens and continue building up the colour of the background foliage on the left-hand side of the picture. Bring the mid tones further down the picture, and introduce a touch of cerulean blue here and there.

11 Starting on the left-hand side of the picture, bring some light green and yellow into the background foliage. Make a mix of raw sienna, lemon yellow, white, terre verte, cadmium yellow and Naples yellow and gently dab it on to the areas where the sunlight, which is entering the picture from the top left-hand corner, is catching the leaves.

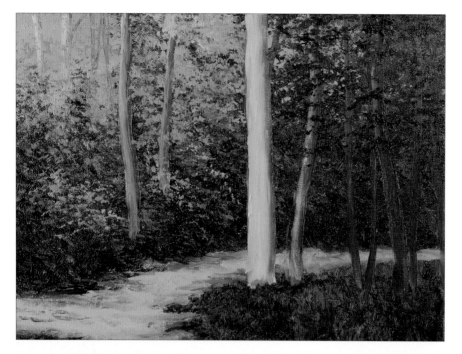

13 Put in the darker, blue-green tones on the foliage on the right-hand side of the picture, overlaying the tops of the tree trunks to bring the foliage forwards. Use a mix of cerulean blue, terre verte and olive green.

Tip

Breaking up the background foliage using a variety of tones and colours makes a more interesting picture, but avoid introducing too much detail as this can be tiring on the eyes.

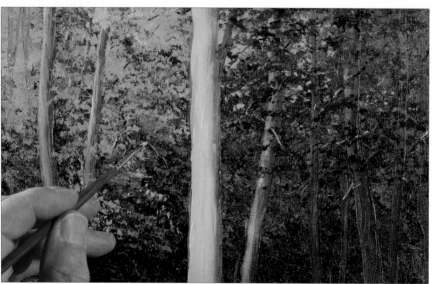

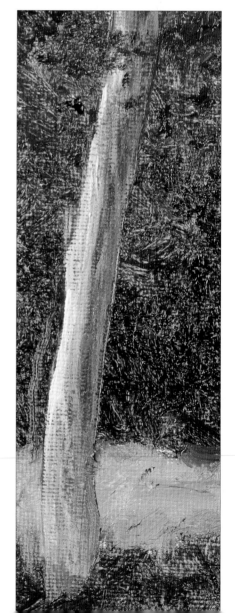

14 Using delicate brush strokes, put in some finer branches amongst the foliage towards the top of the picture using Vandyke brown applied with a soft size 0 round brush. Work on both sides of the painting. Lighten them with a little yellow ochre, then add a touch of Naples yellow for the brightest highlights. Use the same colour to add highlights to the edges of the tree trunks.

15 Build up the colours on the trunk to the right of the main tree. Place a broad highlight down the left-hand side using a mix of Naples yellow and a little white, then add some raw sienna to the mix and introduce more colour on the right. To add an element of drama to the picture, bring in some touches of blue and pink down the right-hand side of the trunk; this will soften the colour and give the impression of reflected light. This will effectively move the shadow (which you added in step 10) so that it lies two-thirds of the way in from the left.

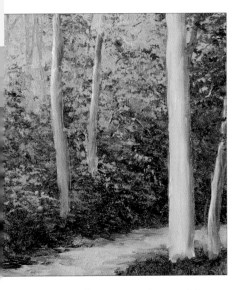

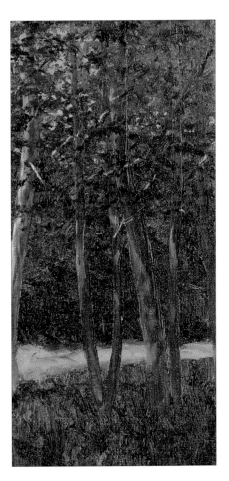

17 For the dark coloured trees on the right, place a glaze of French ultramarine and alizarin crimson down the right-hand sides of the trunks on the right of the picture. Where the sunlight is catching them, use a mix of cadmium red and yellow ochre.

16 Using the same mixes, add more colour to the remaining lighter coloured tree trunks (apart from the main tree in the centre of the picture, which will be painted later). Strengthen the sharpest highlights with a touch of pure white, and finish with a little cadmium yellow, blues and pinks placed here and there to add interest.

Tip

The trees on the right are backlit (see page 30), suggesting light coming from behind them. This technique is a good way of adding interest to a painting.

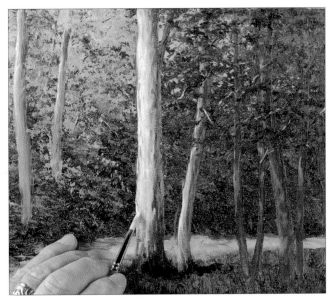

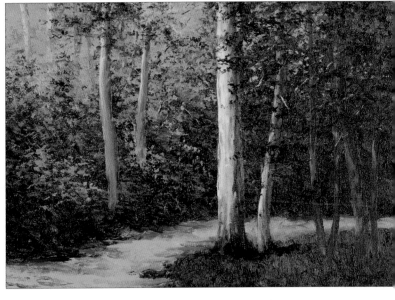

18 Turning now to the main tree trunk, strengthen the tonal values using olive green and some Naples yellow. As you take the colour round to the right, soften it with a little lemon yellow and cadmium yellow. At the base of the tree use olive green, Vandyke brown and burnt umber. Also blend some olive green into the base of the tree on the right. Add a hint of reflected light down the right-hand side using a pale wash of French ultramarine and alizarin crimson. Finish with a few touches of cadmium yellow and place a bright highlight down the left-hand side.

19 Using a mix of terre verte and olive green, bring in more dark foliage on the right of the picture to cover the top of the main trunk. Dab the paint on gently using the stippling brush, as at the start of the project. Repeat on the left of the painting, placing it at the tops of the trees and within the darkest areas of foliage.

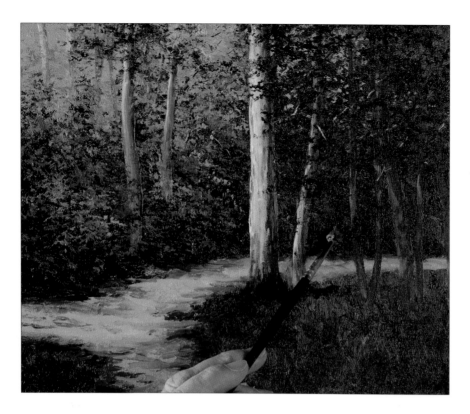

20 Introduce another mid tone into the background foliage on both sides of the picture, bringing the light across from the left into the middle and lower parts of the foliage. Use a mix of terre verte, cerulean blue and Naples yellow. Start on the left, and dab the paint on with the stippling brush. Overlay the trunks to advance the foliage and give the picture more depth.

21 Bring in some highlights using a light green mix of cerulean blue and lemon yellow. Focus on the upper parts of the foliage, where the light hits the leaves, and dab the paint on as before. Complete the left-hand side of the picture, then bring the colour across to the right. Start to give form to the foliage by suggesting the shapes of the branches.

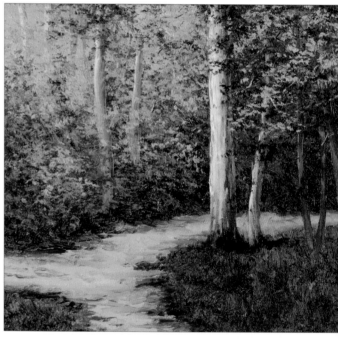

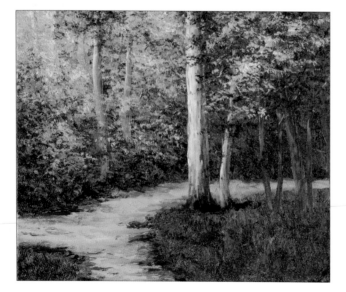

22 Repeat the process using a lighter mix of lemon yellow and white. Vary the mix slightly as you work to create more interest. When you have finished laying on this colour, add a few touches of pure white for the brightest highlights, making these particularly sharp on the right of the picture. To complete the foliage, add a few well-defined leaves at the ends of the branches towards the front of the picture, on the right. Use a fine, pointed brush such as a half rigger or size 0 lettering brush.

Tip

Once you have applied the mass of the background foliage, select a small brush with a good point and deftly add individual leaves to some edges of the foliage mass. This will give the suggestion of leaves without the foliage being too busy.

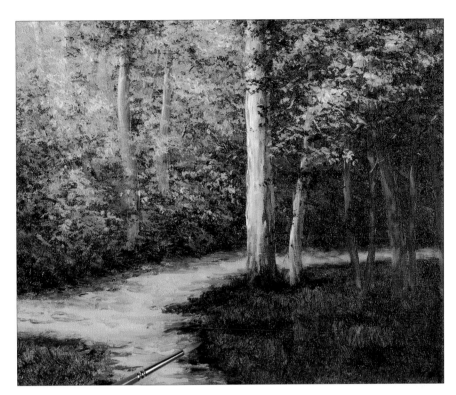

23 Add some shadows at the sides of the path using a mix of French ultramarine and alizarin crimson applied with the side of the size 2 general-purpose round brush. Work the colour into the bottoms of the trees on the left and the grass on the right. Make the mix slightly pinker in places to add interest.

24 Start to put in the strong shadows that lie across the path using a mix of raw sienna and a touch of cadmium red. Dab the paint on gently, taking the paint across the picture from one side of the path to the other. Vary the mix slightly as you work, and introduce some burnt umber at the edges of the path and in the foreground. Use impasto to provide texture towards the front of the picture (see page 57).

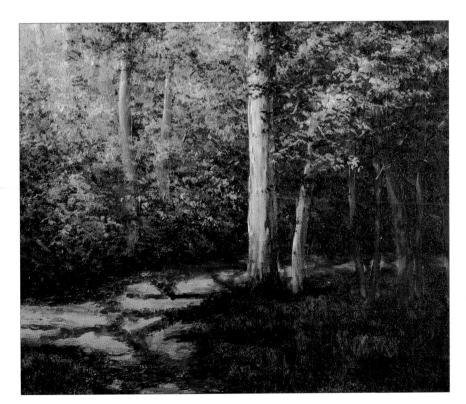

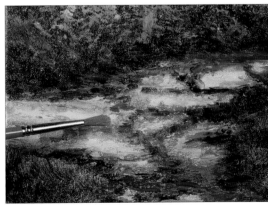

25 Soften the edges of the shadows by gently padding on a mix of yellow ochre and cadmium red.

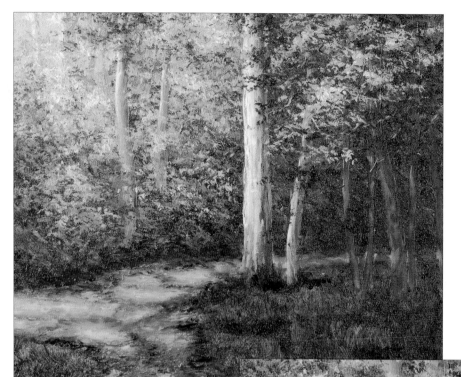

26 Continue blending in the shadows and introduce more colour to the path. Bring in some alizarin crimson mixed with white at the edges of the shadows, and a touch of purple (French ultramarine and alizarin crimson) in the foreground. Define the shape of the path where necessary by bringing in a little of the darker green from the foliage. Blend the colours in using a mop brush, being careful to retain the texture in the foreground.

Tip
Clean your brush frequently as you will pick up the background paint as you work.

27 Add highlights to the path using lemon yellow and white applied with a soft size 0 round brush. Dab the paint on gently with the edge of the brush and blend it in. Place a few bright white highlights on top of the yellow using the tip of the brush.

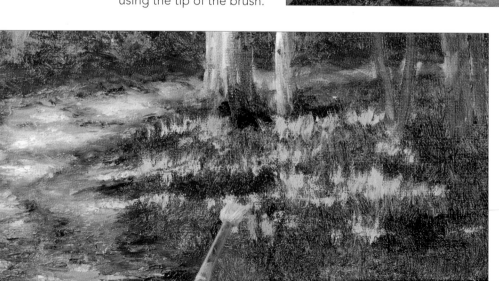

28 Lighten the area of grass that is in sunlight using a mix of lemon yellow, terre verte and cerulean blue. Dab the paint on with the stippling brush using short, upward brushstrokes.

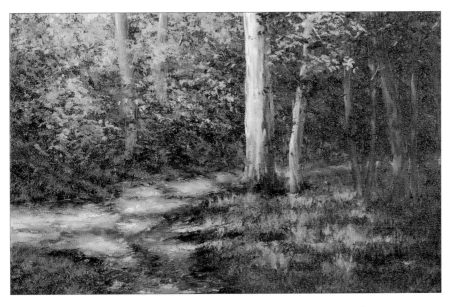

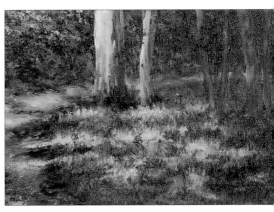

30 Add the brighter tones using lemon yellow dabbed on in the same way, then place one or two white highlights here and there.

29 Bring in the mid tones using a slightly darker green mix of terre verte and lemon yellow. Dab the paint on using the same technique as in step 28, first on the grass on the right-hand side of the picture, then on the small area of grass on the left. Leave the bottom right-hand corner of the picture dark. Finally, place a subtle suggestion of grass under the trees on the far side of the path.

31 Mix some French ultramarine with a hint of alizarin crimson and white and use the edge of the soft size 2 round brush to dab on the bluebells.

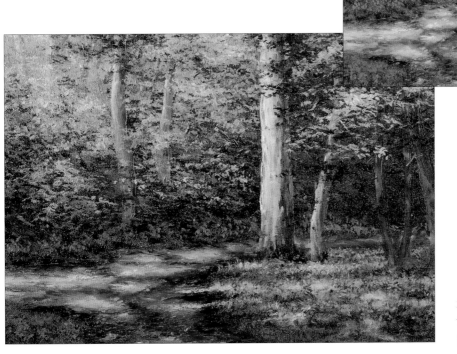

32 Make a lighter purple mix for the highlights, then add in a little pink here and there.

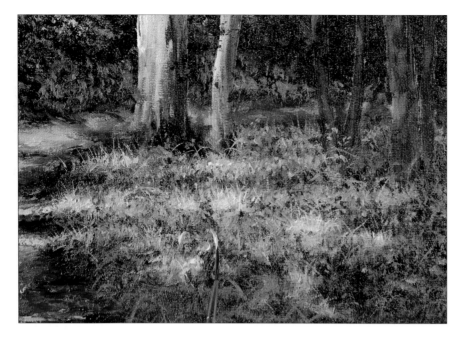

33 Use the fine, pointed brush to put in more blades of grass, blending them in with the bluebells. Use a mix of lemon yellow and white for the lighter areas and terre verte, lemon yellow and cerulean blue for the darker tones.

34 Use the same technique to place some grass stems at the edge of the path under the background trees, and in the patch of grass on the left. Make some of the blades on the left of the picture longer and curve them over the path. Add some tiny leaves here and there to define the undergrowth, and strengthen the grasses and foliage at the bases of the trees on the right – use lemon yellow over the dark areas and a darker green over the light areas.

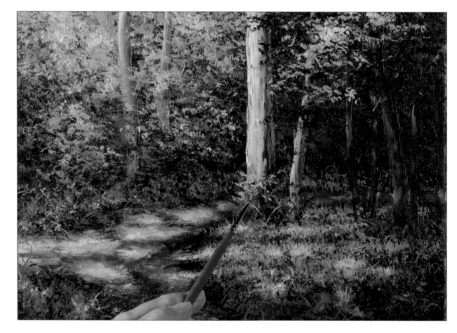

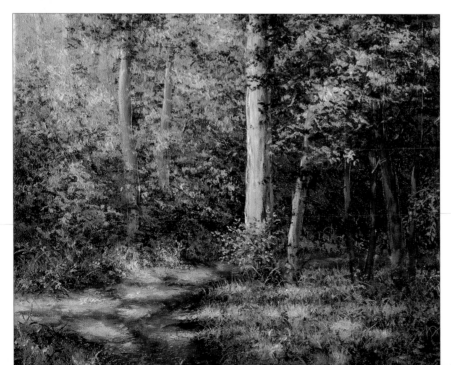

35 To complete the picture, use the fine, pointed brush to put in the bluer foliage on the far right. Use a mix of French ultramarine and Naples yellow. Further strengthen the plants growing around the base of the main tree, and add more tiny, individual leaves at the ends of the main branches. Break up the far side of the path by bringing in a small patch of light about one-third of the way along from the left.

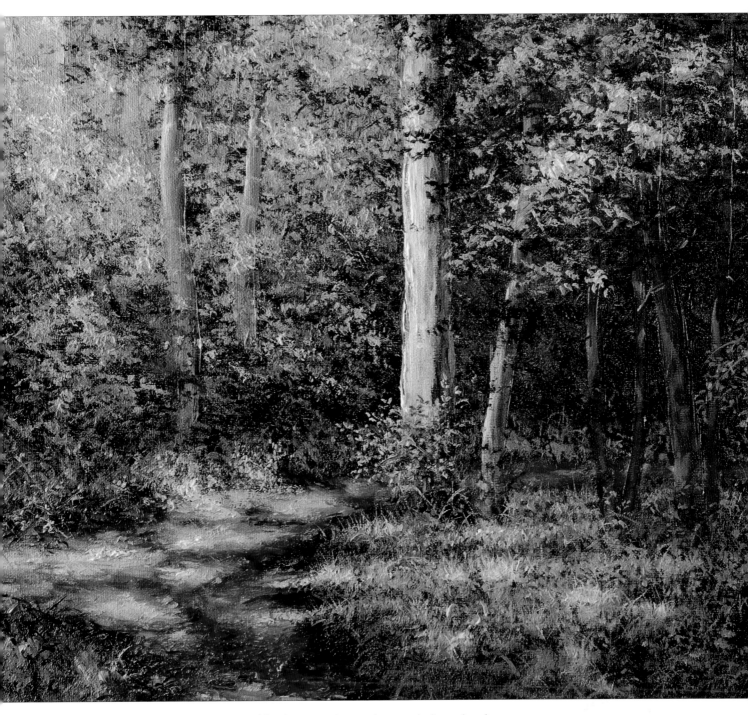

The completed project. Once again, stand back to see the work as a whole and make any final alterations you think suitable. Don't forget to sign your masterpiece!

El Cortijo

We are lucky as artists to be able to study and paint the countryside around us wherever in the world we happen to be. The inspiration for this painting came from southern Spain, in the Almeria region, but it could be anywhere around the northern Mediterranean. The trees are a mix of young and old olives with the cortijo, or farmhouse, just behind. The heat of the scene is suggested by the intense blue sky, hazy mountains and the red and brown foreground. This an excellent painting for using impasto and stronger tonal values in the foreground, and a faint glaze of colour over the background, thereby demonstrating the versatility of oil paints. I enjoyed painting this landscape, and I hope you do too.

You will need

Stretched linen canvas, 30 x 25cm (11¾ x 9¾in) (alternatively, use cotton canvas or canvas board)

Paintbrushes: fairly stiff size 12 flat; size 2 flat/bright; 19mm (¾in) mop; soft sizes 0 and 2 sable/synthetic rounds; fairly stiff size 2 general-purpose round; half rigger or size 0 lettering brush

Palette

Palette knife

Liquin, brush cleaner (e.g. Sansodor)

Kitchen paper

Colours: French ultramarine, cerulean blue, alizarin crimson, titanium white, Naples yellow, terre verte, raw sienna, burnt umber, cadmium scarlet, cadmium yellow, olive green, lemon yellow, yellow ochre, cadmium red, burnt sienna

1 Paint on the sky using the size 12 flat brush. Start with a band of French ultramarine at the top, then blend in some cerulean blue below that, followed by a pale mix of alizarin crimson and white. Add a band of pure white at the bottom of the sky so that it fades out just over half way down the canvas. Blend the colours together using the 19mm (¾in) mop brush.

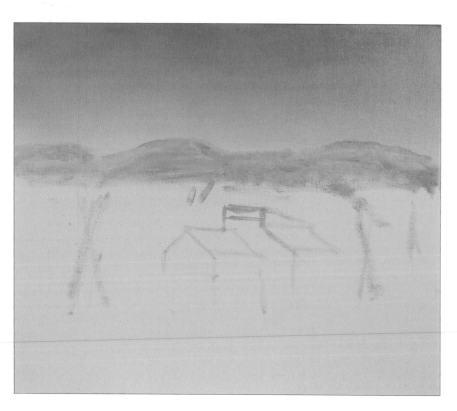

2 Strengthen the top of the sky with a little more French ultramarine and blend it downwards into the lighter areas. Map in the mountains using a pale mix of French ultramarine and a size 2 general-purpose round brush. Position the mountains so that the pink part of the sky is just visible behind them. Map in the farmhouse and the main trees. These are only to help you visualise the finished painting and therefore do not need to be in their final positions.

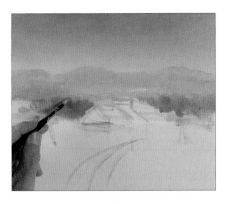

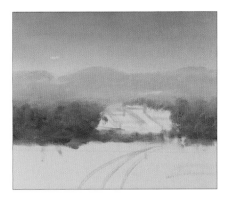

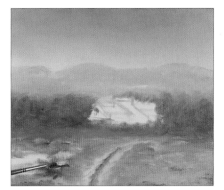

3 Map in the track, then put in the middle ground behind the farmhouse using the size 12 flat brush and a soft purple mix of French ultramarine, alizarin crimson and titanium white. Apply the paint firmly using short, horizontal brushstrokes. Add in some patches of pale pink, Naples yellow and white, taking these colours up into the base of the mountains.

4 Continue to strengthen the middle ground, deepening it with the addition of a little French ultramarine as you progress down the painting to just below the farmhouse. Introduce some terre verte mixed with a little raw sienna where the trees will lie, either side of the house.

5 For the foreground lay a base colour of raw sienna and white using the size 2 general-purpose round brush. Lay on the paint thickly, expecially at the front of the picture, to create texture (see the tip below). Avoid painting over the track. Separately drift in a little terre verte, burnt umber and white here and there to break up the brown, and blend it in to the purple mid ground.

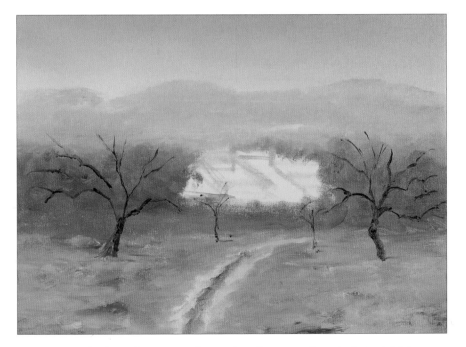

6 Bring in a little cadmium scarlet and cadmium yellow, lightly dabbing on the raw colour in patches. Tone them down using a more neutral colour over the top, then map in the tree trunks and main branches of the olive trees. Use the tip of a half rigger (or lettering brush) and olive green paint.

Tip

To build up texture (impasto) and colour, loosely mix two or three different colours, then load your brush with paint and half stipple, half drag the brush lightly over the surface of the painting using sideways brushstrokes. Use a wider brush for pathways or tracks, but be careful not to over-do this technique.

Tip

Continue to add in tiny amounts of Liquin to your mix every now and then, and to clean your brush before changing to a new colour (see page 13).

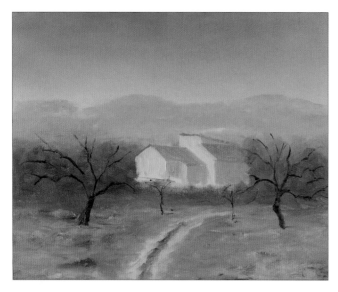

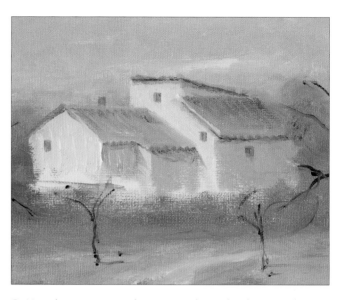

7 Outline the farmhouse to redefine its position using a purple mix of white, French ultramarine and alizarin crimson applied with the size 2 general-purpose brush. Put in the side walls using white and a little Naples yellow, for the front of the building (facing right) use the purple mix, and for the roof use Naples yellow and cadmium scarlet. Strengthen the edges of the roof using the same colour applied with the soft size 2 round brush. Simply block in the shapes at this stage – no detail is required.

8 Use the same purple mix to place shadows under the eaves and to add the tiny windows and the chimney. Use the soft size 0 round brush. To suggest tiles, make the bottom edges of the roof irregular and add some lines to create ridges.

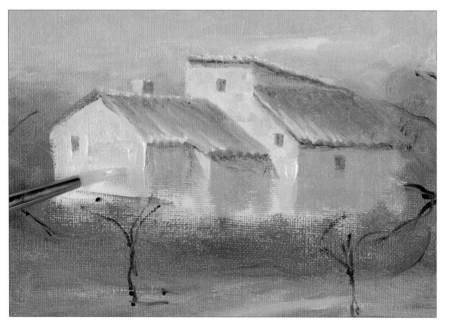

10 Add a pink glaze to the sky. Use a thin mix of alizarin crimson and white and apply it in patches with the soft size 2 round brush. Blend the colour in and smooth it out using the mop.

9 Pad a little more colour on to the sunlit walls of the house using lemon yellow and the size 2 general-purpose round brush, then introduce some Naples yellow mixed with cadmium scarlet and white followed by cadmium yellow and white to build up the colour. To the shaded walls apply patches of alizarin crimson mixed with white. Strengthen the corners of the building as you work. Switch to the soft size 2 round brush and add pure white highlights here and there, including the top of the flat roof. Use Naples yellow and white for the highlights on the sloping roof, applying the paint along the lower edge and dragging it upwards. Strengthen the shadows on the roof using a purple glaze.

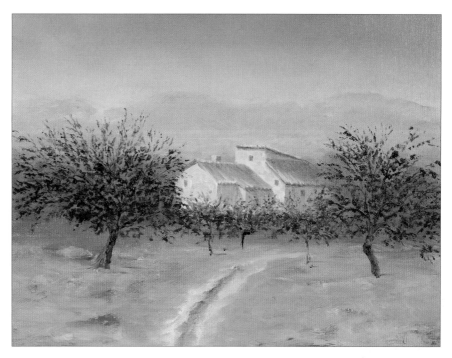

11 Change to the size 2 flat/bright brush and start to add the foliage to the trees. Begin with the mid greens using a fairly dry mix of terre verte, cerulean blue, French ultramarine and olive green. Dab the paint on along the branches to define the shapes of the trees.

12 Continue building up the dark foliage on the trees, extending it to partly obscure the base of the distant mountains and the lower part of the walls of the house. Ensure there are no large gaps between the trees – add extra trees if necessary.

13 Darken the denser, inner parts of the trees using olive green. The light is coming from the left, so do this mainly on the right-hand side of the trees.

Tip

Experiment with gently brushing some edges into each other, such as the mountains and the sky on the horizon. It is best not to do more than a third as the painting can adopt an unfinished look – it needs to be just enough to leave the viewer to imagine the rest.

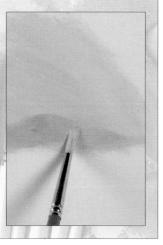

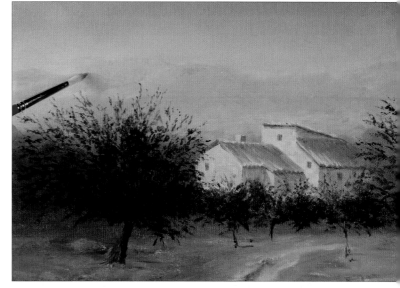

14 Change to the size 2 general-purpose round brush and strengthen the background mountains using a light purple wash of French ultramarine, alizarin crimson and white. Dab the paint on gently and add some touches of pink here and there.

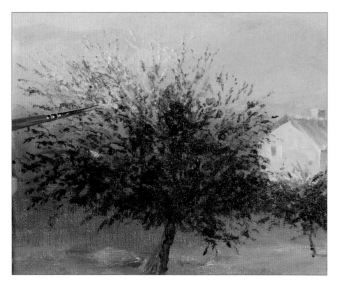

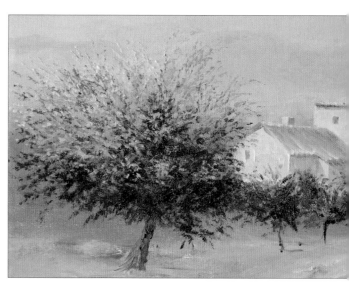

15 Place the highlights on the left-hand tree using a soft size 0 round brush. Lighten the parts that are in sunlight (mainly on the left) using a mix of lemon yellow, white and terre verte. Dab on the paint gently, starting with the tiny leaves at the ends of the branches and working inwards towards the centre of the tree. Fill in any large gaps with the mid green used in step 11.

16 Continue to build up the highlights on the left-hand tree. Vary the mix slightly to obtain different tones, making it slightly darker towards the centre and top right-hand part of the tree by adding a little more terre verte and some olive green. Build up the colour until the tree has a solid, three-dimensional form.

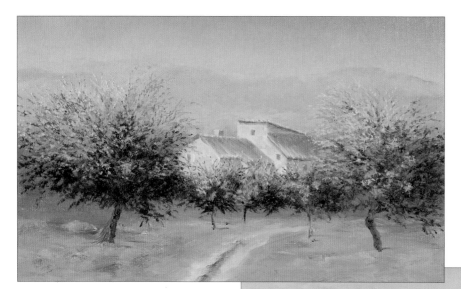

17 Add highlights to the remaining trees following the same technique, giving them form and depth. Introduce a little raw sienna in places for more variety of tone. Extend the tops of the smaller trees by adding some very fine branches and dots of foliage to partly obscure the lower parts of the house.

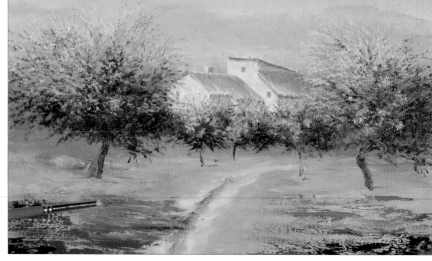

18 Build up the colour and texture of the foreground. Apply the unthinned paint thickly, initially using yellow ochre, raw sienna and burnt umber, focusing particularly on the very front of the picture. Refer to the tip at the bottom of the facing page.

19 Continue building up the colours in the foreground. Introduce some cadmium red and pink, knocked back by overlaying it with yellow ochre, cadmium yellow, Naples yellow and cadmium scarlet. Blend the colours together using small, vertical brushstrokes to suggest grass.

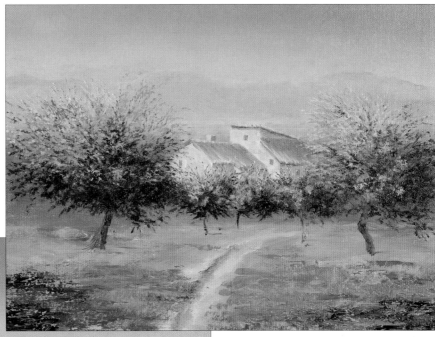

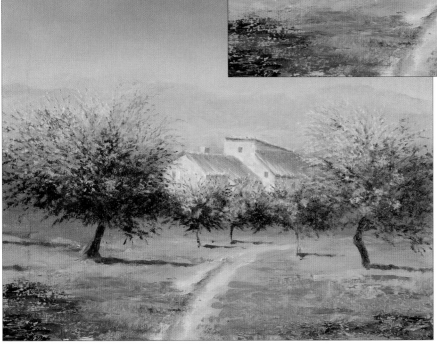

20 Using a mix of alizarin crimson and French ultramarine and the size 2 general-purpose round brush, put in the shadows of the tree trunks. Include some shadows extending from trees that are just out of sight on the left of the picture. Place a purple glaze down the right-hand sides of the trunks using the same mix.

Tip

To build up texture in the foreground of a picture, apply thick layers of colour using unthinned paint. Hold a flat, fairly rigid brush flat on the canvas and drag sideways to achieve an impasto effect. Be careful not to overwork the paint – remove any excess paint with a palette knife.

1 Begin by dragging on a thick layer of burnt umber. Work horizontally across the picture.

2 Repeat with a layer of cadmium red.

3 Finally, add layers of yellow ochre, Naples yellow and cadmium scarlet.

4 Remove any unwanted paint with a palette knife.

21 Build up the colour of the ground under the trees using the size 2 flat/bright brush. Bring in hints of terre verte and yellow ochre, followed by touches of yellow ochre mixed with cadmium yellow, and finally cadmium scarlet, yellow ochre and cadmium yellow. Dab the paint on in places to suggest grass, and elsewhere drag it on sideways to achieve a patchy finish. Define the track a little more, but without making it too distinct.

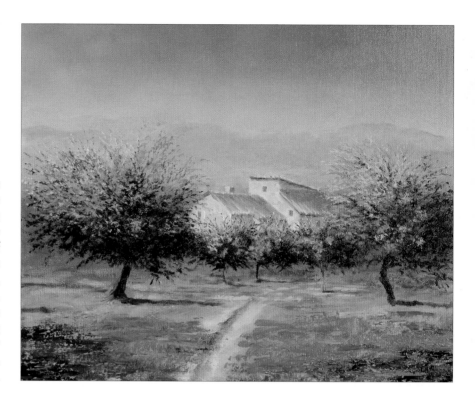

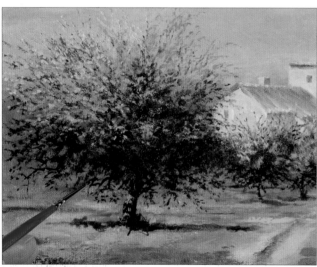

22 Strengthen the main tree trunk using olive green and add the lower branches and a suggestion of grasses growing around the base. Use the soft size 0 round brush. Extend the shadow slightly to the left of the tree. Repeat for the remaining trees, then add some olive green to the shadows to increase their tonal value. Finish by placing tiny, individual leaves at the ends of the branches using the half rigger or lettering brush (see page 51).

23 Continue to build up the area of ground under the trees using lemon yellow and yellow ochre applied with a firm brush. Bring in some raw sienna on the unpainted parts of the path, and a hint of burnt sienna on the foremost section. Lighten the path with lemon yellow and a little white, dabbed on with the side of the brush. Strengthen the foreground here and there if necessary, bringing in different colours for variety and interest and reinforcing the impasto effect.

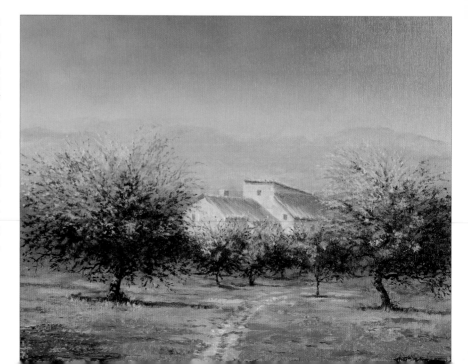

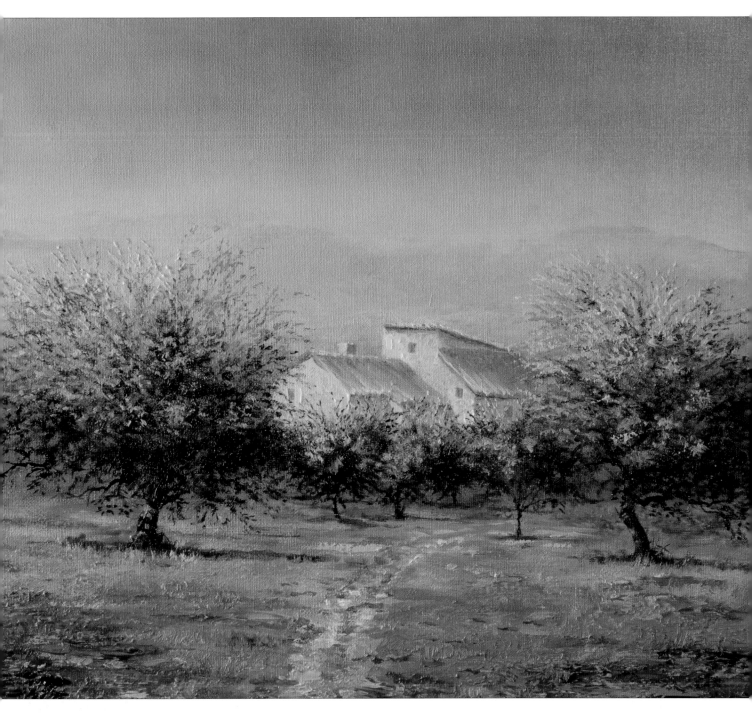

The completed project. Step back and cast a critical eye over the whole painting, and over individual sections. I sometimes leave a painting to 'rest' for a day or two and look at it afresh before making any final adjustments.

Index

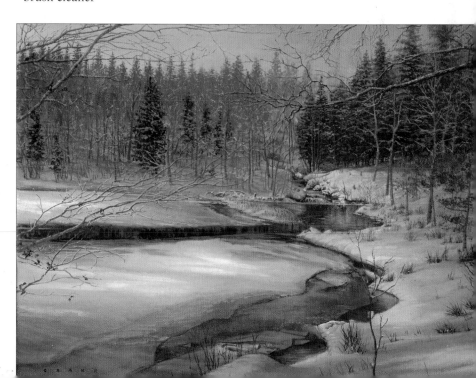

A Swedish Snowscene